MAKING

&

Duro
Olowu

UN

MAKING

Contents

Foreword

Duro Olowu's talk with Glenn Ligon at London's Tate Modern
in early 2015 was inspirational; their shared passion for textiles
connected a richly illustrated conversation about pattern,
repetition, politics and process. This take on art and its creation,
formed from a particular understanding of the relationship of
fabric to society and to the body, underpins the choices Olowu
has made in shaping the exhibition *Making & Unmaking*.

While it is unclear exactly when the craft of weaving was invented,
there is evidence that woven cloth has been in existence for
at least 12,000 years. The creation of thread or yarn must have
come first, the outcome perhaps of playful manual dexterity and
experimentation with gathered sheep's wool and twisted plant
fibres. The first weavers, having observed the basic principles
applied to the interlacing of twigs and branches to form shelters
and baskets, used their fingers as a structure to make narrow
strips of fabric.

According to Olowu, this immediacy of making is present in
many examples of his selected works in which the hand of the
artist is felt. He says:

> The more I looked at a work, the more the intricacy and
> beauty of discovering what the artist is capable of while
> making it came through to me. [...] Often I see something
> that [the artist] may not have considered ever showing,
> something nobody had seen or that people had seen
> but overlooked. I would feel that the hand of the artist
> had touched it and realise that it was exactly what I
> wanted to show.

The paintings, photographs, jewellery, sculptures, tapestries, fabrics, ceramics and more that constitute *Making & Unmaking* are all things that have been seen from the corner of Olowu's eyes or are linked to images and ideas that have been lodged in his memory from childhood or from travels. Anyone visiting his design studio in London will sense his treasure-trove mind; his latest clothing collection hung among an ever-changing selection of traditional textiles, vintage jewellery and artefacts, all cleverly placed alongside current work by contemporary artists and ceramicists, to form a memorable visual feast. Olowu has exercised this same magic in weaving together an array of components to create an exhibition and publication full of pattern and texture, and evocations of places and histories.

To bring together the work of more than 60 artists for an exhibition and to assemble a comparable book requires the dedication and generosity of a large number of people. First and foremost thanks go to all the artists for their valuable studio conversations with Olowu, their enthusiasm for his ideas and their readiness to contribute works that have enriched his vision for the show.

Gina Buenfeld at Camden Arts Centre, assisted by Charlotte Juhen, has worked tirelessly alongside Olowu, securing loans from private and public collectors, and gathering together material for the publication. The response and support shown by the various lenders to the exhibition and the artists' representatives, all of whom are acknowledged elsewhere in this book, has been extraordinary. The exhibition has truly benefitted from the determination shown by gallerists and curators to assist with securing Olowu's desired works.

This intelligently constructed publication has been brought into being by A Practice for Everyday Life, together with Doro Globus and Daniel Griffiths at Ridinghouse, who have imbued the book with their own enthusiasm for the subject and material. So too have Jennifer Higgie and Shanay Jhaveri, whose essays add new layers to Olowu's collage of thoughts. Glenn Ligon, already implicated in the conception of the project, has also readily shared a relevant section of an ongoing dialogue for inclusion amongst the texts.

Making & Unmaking has been an ambitious undertaking and could not have been fully realised without the financial support and gusto of a group of individuals who are part of the Exhibition Supporters Circle. Working with Duro Olowu on this project has been an exciting adventure and a privilege for every member of the team at Camden Arts Centre. All along, Olowu has been true to his own vision and passion, whilst also keeping in his mind the Centre's history as a place where artists and making are at its heart. His acknowledgment is exemplified by the number of artists in the show – such as Caroline Achaintre, Alexandre da Cunha, Yinka Shonibare MBE, Tal R, Dorothea Tanning and Francis Upritchard – who have showed or been resident at Camden Arts Centre at other times, exhibited alongside artists who are on a dream list for the future. This, along with the inclusion of influential figures like Anni Albers and Lygia Clark, echo the patterns and threads within the Centre's established artistic programme. It is thrilling to have *Making & Unmaking* as the exhibition that completes Camden Arts Centre's celebrations of its fiftieth year.

Jenni Lomax
Director, Camden Arts Centre

DURO OLOWU IN CONVERSATION

WITH GLENN LIGON

Glenn Ligon Tell me about the title of the exhibition, *Making & Unmaking*.

> **Duro Olowu** The title was a real dilemma. Since I come from a fashion background, the assumption was that this show would be about artists who use textiles, but it is more about that process of personal ritual that an artist goes through, which is like the act of weaving. I was reticent about using words like 'cloth' or 'thread' or 'loom' in the title because I thought everyone would walk in and expect to see that, or just perceive the show as being about one thing.
>
> When I was thinking about the title, I went to a discussion that you had with the artist Lynette Yiadom-Boakye at Haus der Kunst in Munich last February [2016], where the director Okwui Enwezor gave a brilliant introduction. He spoke about how artists arrive at the artworks that they make; how the gestures, the strokes and what is being represented all come together. He said it was the artist trying to 'balance the tension' – and at first I thought, 'That's it! That's what you do on a loom: balancing the tension'. Okwui's words seemed to encapsulate certain ideas that I had about this show. And then, even better, you asked Lynette a question about her process, and she said that she knows what she wants to achieve in her work but never quite how it will turn out. She rarely repaints things, but playing with colours gives her something that she never thought was possible. She said, 'It's a sort of making and unmaking of the work even before the public has seen it'. I thought 'That's it!', and that's the origin of the title. I stole it from Lynette!

GL So let's think then about the idea of 'making and unmaking' in relation to some of the artists that you have chosen. We have a huge range of artists working in a variety of mediums – some with photography, some working directly with weaving, some incorporating fabrics into sculptural objects, while others refer to patterning that comes from fabric-making (whether in print, paint or ceramic). How does this idea of 'making and unmaking' apply to the variety of ways that practitioners are creating works?

> **DO** The important aspect of all of this – and this is why the show, for me, is quite liberating and such a great opportunity – is that I wanted to bring works together in a way that made the artists feel good about the context, the relationships and the presentation.
>
> A lot of the works already have strong political undercurrents and a whole confluence of themes – addressing gender, race, beauty, sexuality

and the body. The artists already know this is what their work is about, but they go through tactile and intellectual processes during the making of these charged works. It has to do with the hands or mind and the way they work. I found it quite incredible that the more I looked at a work, the more the intricacy and beauty of discovering what the artist is capable of while making it came through to me. As trained artists there can be the assumption that you have everything figured out. Over the last 80 or 100 years you have art schools that produce prolific artists that are taught in a certain way but, in *Making & Unmaking,* I'm looking at the training that is done by the artist within their *own* space – both mental and physical.

GL I noticed that a lot of the artists you've chosen are working on things that are seemingly handmade, such as Sheila Hicks's *Cordes Sauvages/Hidden Blue* (2014; p.79) or James Brown's collage work *Some Neighbors in the Garden of My Other House* (2013; pp.56–57). That is a sensibility that has a relationship to how you work as a designer, but is that something you were looking for in terms of thinking about what was going to be in the show?

DO I have to say yes, but not consciously; it was fortuitous. When I visited artists' studios I could tell that they were a bit nervous, even if they were renowned, respected artists. They were thinking: what does he want me to make? Often I see something that they may not have considered ever showing, something nobody had seen or that people had seen but overlooked. I would feel that the hand of the artist had touched it and realise that it was exactly what I wanted to show.

GL Do you think those works were sometimes things that the artists themselves had overlooked?

DO Yes. To me that's the great thing about being a good artist and a great executioner of technique, flair, emotion and depth: you cannot be too certain of your potential.

GL Or it just means that artists are hoarders: we're afraid to throw things out because they might actually be work. The germ of the idea might be in a piece that was put aside. It may not have flowered yet, but, you know, put that bulb in some soil and maybe it will. Often, as an artist, you are trying to make something that you haven't seen in the world. It is a lot easier to rely on what you've already

done but the truly interesting artists push beyond what they've done and try to find new things.

> DO Absolutely. You know, look at Marina Adams or Christiana Soulou and you think, 'How does one persist with an investigation of one type of gesture, and from that gesture get such a variety of emotion?'. It's incredible.
>
> The real dilemma for a lot of artists is what to do with work that seems outside of their practice. For example, I walked into Caroline Achaintre's studio – who is best known for her ceramics, tufted wool-work and small drawings – and saw this distorted and mangled, 1920s-Berlin-performance-meets-Shoreditch object and asked, 'What's that?'. She said, 'I don't know. I haven't shown any of this work, but I really feel that I want to fill fabric with something on the inside'. I thought that various artists have done this type of work but in a very different way; Achaintre's *Lemac* (2015; p.38) is a contemporary take on it. As an observer, contemporary artists' processes feel very different from somebody who was working 50, or a 100 years before.

GL Part of that may be a breakdown of genres between various ways of making objects. Many artists I know paint, sculpt, do video. The distinctions between genres are less important to them than they were in the past, but also the making has to do with finding people to collaborate with. Recently I started doing some tapestries, and it was amazing to realise that, although I am working abstractly and thinking about abstract marks, the marks can be translated into a woven and dyed fabric. The collaboration that is required to make that work is interesting to me in ways I hadn't initially anticipated. But for me, it is still unresolved.

> DO It must have been quite liberating in that you didn't know how it would turn out, but you could also see how your ideas were being formed by these hands.

GL Yes, it was like watching the movie adaptation of a novel you have written. I think that a lot of artists are willing to stretch themselves into new mediums, new territories, as a way to expand possibilities. I think that it is more productive for me not to know everything about a particular medium because then I haven't inherited a set of rules about how to make something. A lot of artists that I respect figure out ways to keep their production fresh, either by putting something to the side for

10

a while or, in the case of an artist like Lynette Yiadom-Boakye, setting parameters around how he or she paints. Lynette paints a work within a day and then moves on to the next painting, whether the issues in the previous painting have been resolved or not. It is a really interesting – but demanding – way to keep one's work moving forward.

This idea of stretching one's self brings up an interesting link to your curatorial practice. *Material* (2012) was your first curatorial project and *More Material* (2014) was the second. I anticipate, as in those two previous shows at Salon 94 in New York, the exhibition at Camden Arts Centre offers an incredible opportunity to see new material but also re-evaluate material that we may have thought we knew. How did you start curating?

> DO Reluctantly! Jeanne Greenberg Rohatyn at Salon 94 said that we should do something together and I kept saying, 'No, I'm not in the art world'. For various reasons, I thought I wanted to retain the ability to love art as an observer and to be someone who walks into a gallery or museum and thinks, 'Wow!'. Jeanne eventually said that she would give me the space and let me put anything in it. That's how *Material* started and that was just me playing, but it turned into a rather big and well-received exhibition.

GL Both *Material* and *More Material* brought together a range of artists and craftspeople – designers, ceramicists, photographers, painters – to be in dialogue with one another. In some ways, to be a curator is to have a kind of third eye because a lot of the artists that you are working with in the show are very well established. So the question is how then to bring that work into new discussions? How to make it relevant to what's going on in the world at this time, both culturally and politically?

> DO I really don't see myself as a curator – well, I didn't! To be honest, my thought process is very different to that of a traditional curator: I can let the themes go left; let them go right; they go up; they go down; sometimes they disappear; other themes are brought in; and there are no rules. That is probably different to what a curator within a museum can do. I'm not trying to say that my approach is better or more interesting – the fact is that I do feel a sense of freedom when I'm working in this manner. There are no constraints on what I can tackle – genres, eras, dates – and, even more importantly, I can surprise myself by including works that I would not have considered at the start of the process.

11

GL Let's talk a bit about how this impulse to curate came about. You have a thriving career as a designer, and you've taken on a lot to do this exhibition at Camden Arts Centre. What is that impulse about?

> DO To be honest, it came from growing up in spaces where very different things were put together. In my world, in all my spaces, I put things that are very different together: ceramics, art, textures, fabrics, photographs, books, jewellery. They are things that I feel have a sort of grounded integrity coupled with amazing aesthetic beauty. I always thought that it was normal and everybody could do it. If you're being creative, you have to truly see the things around you in a different way, otherwise you are just using them.

GL What was it about Camden Arts Centre that made you return to curating?

> DO I love the space. Do you remember that talk that we did at Tate Modern in May 2015? It was very important because afterwards everyone – including Jenni Lomax, the director at Camden – went on about how great it was to hear you talk about other things that you were interested in outside of the art world. After that Jenni saw me at another function and said, 'Okay, Duro, please. I'd like to you do to something, you can have the whole space.' I said yes, of course!

GL What excites you about Camden?

> DO I always think of Camden as the kind of place that the avant-garde poet Edith Sitwell would have walked through – but in platform shoes. It is *so* contemporary but also reminds me of walking down my school's corridors. When you look at the roster on the wall of people that have shown there in the years gone by it is amazing. Félix González-Torres, Richard Tuttle, Kara Walker… I mean, it's *unbelievable*! The fact that it has such a high percentage of people in that local area of Hampstead and Swiss Cottage that are their visitors does say something too. I don't know how you feel about the space, but there's something about it that is special; it doesn't feel like it's bogged down by institutional criteria.

GL A number of artists I know who have worked there have felt a generosity around the projects they wanted to do and an openness regarding what they could propose for their exhibitions, even if it was the most far-fetched idea.

12

DO Well, to start with, they have let me select work from a large number of artists, mixing the classical and contemporary. Talk about generosity! I certainly have felt an openness from the team vis-à-vis my ideas for the show and the possibilities within the space. What was it like for you?

GL It was an amazing experience because I initially thought that my show was going to be of existing work, and by the end it was all new work. I'm not sure exactly how that happened! Your show has expanded as well; there are over 60 artists included in it. Let's talk about the medium of photography for a moment and its role in *Making & Unmaking*.

DO The work of photographers such as Claude Cahun, Irving Penn and Neil Kenlock were crucial to the formation of the exhibition. Cahun worked in different media as an artist but she was best known for her photography. She had a life that was colourful, but also very true to what she believed in and conveyed this all in her work – issues of sexuality and identity – with a surrealist tinge. Neil Kenlock captured the British Afro-Caribbean community in London in the 1960s and 1970s. He saw what he was doing as creative, but, perhaps, he didn't necessarily see himself as an artist; it was a job, like being a jewellery-maker. But he photographed powerful reminders of issues surrounding identity, often in gloriously representational domestic settings that are very familiar to me, due to my part-Jamaican heritage. Meanwhile, Irving Penn's work, to me, is a lesson in the personal ritual of someone seeking perfection in composition and execution; he always wanted to get everything just right and really worked at it.

GL Glancing at the checklist there are a number of artists that I know but the things you have included in the show by those artists is work that I have never seen before. For example, I know Dorothea Tanning as a painter but I don't know that much about her fabric works.

DO I am always looking at Dorothea Tanning fabric sculptures. I love the paintings, but there's something quite profound and twisted about this type of her work. Getting to know artists, I have learned that they have a deep interest in clothing and fabric. They are intrigued by how something that starts out flat can become a completely different form and role.

GL It turns into *something*.

DO Exactly – which they don't feel they can achieve unless they make a sculpture.

GL You know this too because artists are coming through your shop in London all the time.

DO Yes and with a lot of the artists I meet, the first thing they say is that they love the clothes. They will ask, 'How do you do this? How do you mix the patterns and print? Why do you put this turquoise with this blue? How come you mixed velvet with silk?'. They are all very curious about the process – I am always very surprised about this.

GL I am surprised that you're surprised that artists respond to your work, because you think so much like an artist in terms of the research you do on design, the collaborations with various craftsmen you are involved in, the sense of collage that informs your work. Artists are often in dialogue with people who they respect, even if those people are not artists.

DO That is probably true. I am thrilled to be part of this type of dialogue, which wasn't obvious to me in the beginning. The truth is that some of the most inspiring shows that I've seen have been ones that deal with this kind of discussion, or this dialogue between art and fashion; art and textiles; art and music; art and the environment. There is a whole range of work that has been shown in some of the greatest institutions in the world and you go and you're blown away. With me, the aim of showing the work of artists in this way is to let the viewer to see each piece for what it is and respect it as a thing of beauty.

GL I think you're on to something because artists are connoisseurs. There are so many artists I know who are, for example, nineteenth-century book scholars, or collectors of quilts.

DO You collect! Artists are the *best* collectors of art and ephemera. When you see how they put things together in their homes and studios, it adds a new dimension to what you thought their work was about.

14

GL Well, I think because whatever one collects as an artist is about ideas for future work. I find it fascinating that you are drawn to work that an artist might have to the side of the studio, or work where the ideas are still a bit raw. We know, as you were saying, Dorothea Tanning's work. We think we know what her production is but as a curator to look for the thing that's not out in the world is interesting. For example, I didn't know that Anni Albers made jewellery.

DO Anni Albers was first of all an extraordinary artist in every way and, unfortunately, a victim of her time. The Bauhaus wasn't very generous. It had some great women artists, but women artists in the Bauhaus were meant to just make domestic objects. They weren't supposed to make industrial or artistic things that changed the world. Anni Albers, whose work I discovered many years ago, is someone I've really come to admire because I feel the challenge for women artists is very different. Josef Albers was a fantastic artist but very professorial: his paintings were very geometric and mathematical. Whereas Anni's work – whether it's the weaving, the little paintings and drawings, the jewellery or the tapestries – shows a need to make something and to form a kind of relationship with your body that allows you to make it.

Nicholas Fox Weber, who heads the Josef and Anni Albers Foundation, told me that at the start of their relationship Anni made necklaces from scratch, and then sold them on the streets so she could save money to take Josef to visit her parents. Some of the greatest artists had gone through poverty and sometimes you can see that in the work, but then you also see the other side, which is this ability that comes from constant practice and belief. In her case, it was a very personal and quiet way of working, using simple materials to create such special and moving pieces. You don't know why what you're looking at is so moving but the fact that it can have this effect is rather amazing.

GL One of the aspects that's quite striking in the show is the number of ways that the body is represented. You could look at Malick Sidibé's representations of women in the Vues de dos photography series (2001–08; p.75) or you could look at the ways painters like Chris Ofili and Lisa Brice are representing the body in patterns, in fabric. Can you talk about the different ways these various artists use painting, photography and so on to represent the body, but also talk about the ways in which textiles and fabrics appear in those different modes of working?

15

DO Textile and pattern in works by Ofili and Brice don't appear like those in paintings by Van Dyck and the Old Masters. The latter created painted characters in stately postures with textiles and in clothes that enhanced the status of the sitter. In *Making & Unmaking*, I wanted to highlight how contemporary artists represent textile and pattern in their work. To me, selecting and wearing clothes in real life is the most powerful and emotionally truthful expression of personal identity.

Looking at some of the portraits in the show, what strikes me is that not every aspect is painted or detailed with pattern, but the right bits are – that is a skill. Alice Neel is a master of this. In *Richard with Dog* (1954; p.19), the way she painted the clothing of her subjects conveyed much more than the era, rather, one feels the sexual and political undercurrent, which adds to the beauty and skill of its execution.

Meredith Frampton was a great painter in the 1920s, who is someone that I only discovered through research for the show. His portraits are of quintessential English women, usually doing things everybody at that time expected: playing the violin, looking beautiful yet forlorn. However, in a work like *Winifred Radford* (1921; p.41), there's something else going on in the background that makes you think, 'Something isn't right'. The rich and stark portrayal of her body and the clothes – even without pattern – says that the subject is someone who carries the burdens of her gender, sexuality and era.

GL I appreciate the historical range of the show as well as the variety of objects in it. You have included older or lesser known work you feel can be in dialogue with contemporary works. It is inspiring to me to see these various things put together.

DO With my work, I often combine and juxtapose my own fabric prints with rare vintage ones from my private collection. I've always felt that, by including these outstanding examples of quality antique fabrics in a piece of mine, what I make needs to be in harmony with the technical and aesthetic beauty of what I'm using from the past. I find that when artists are also working with materials that they're not used to, they try and achieve the same thing they have in their other work. This process of discovery and experimentation is very empowering and that is what *Making & Unmaking* is ultimately about.

April 2016

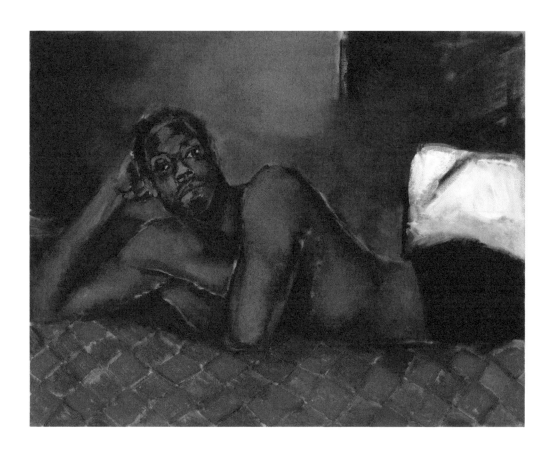

Lynette Yiadom-Boakye
Tie the Temptress to the Trojan, 2016

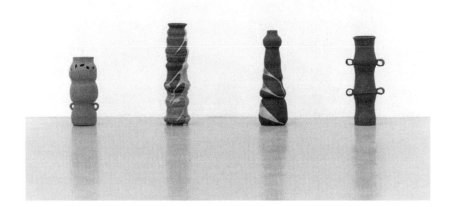

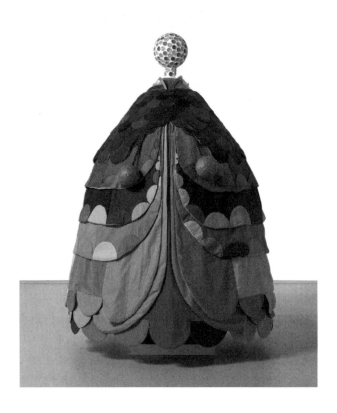

Top to bottom:
Tommaso Corvi-Mora
Guards, 2015–16 (detail)

Tal R
Freda, 2009

Opposite:
Alice Neel
Richard with Dog, 1954

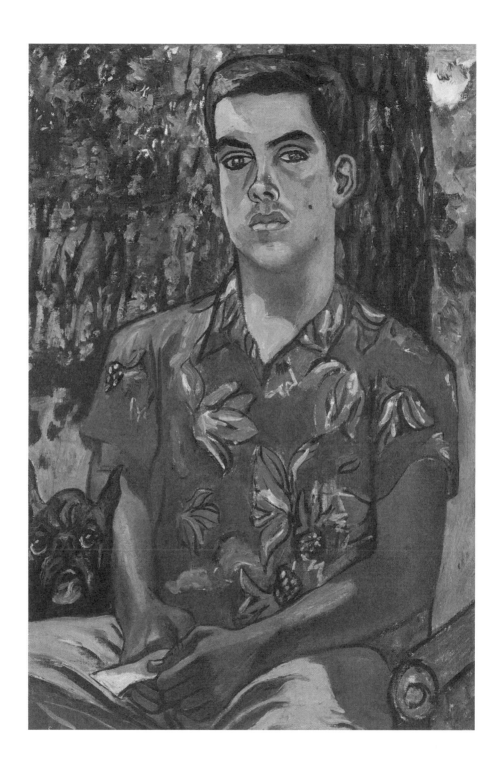

19

Top to bottom:
Lorna Simpson
Nightmare?, 2013
Cliff, 2016
Speak You This with a Sad Brow, 2013
Beauty in a Box, 2016

Opposite:
Claude Cahun
Self Portrait (kneeling, naked, with mask), 1928

20

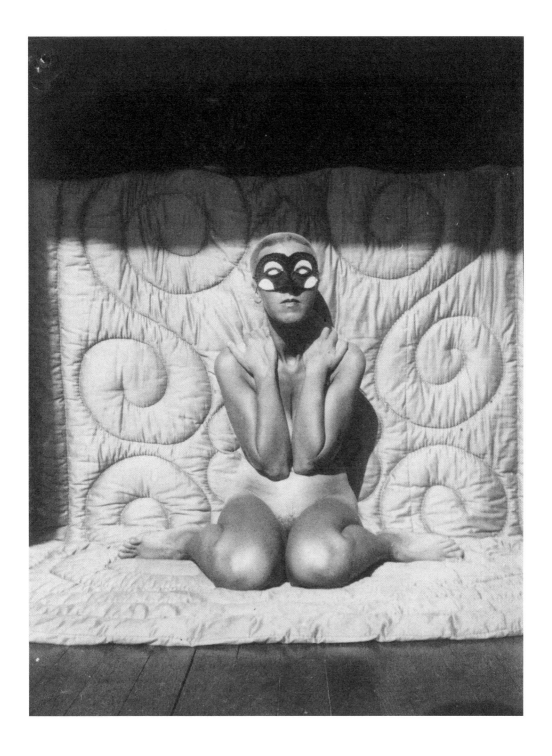

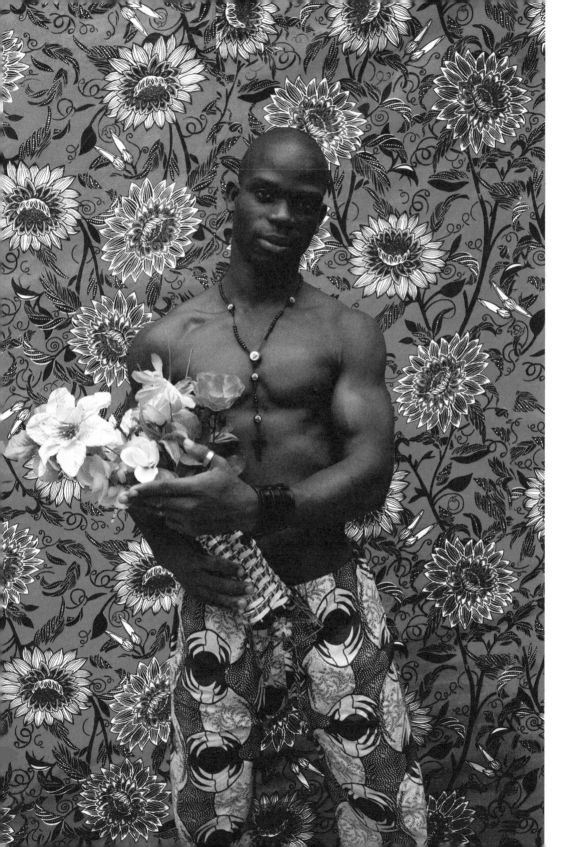

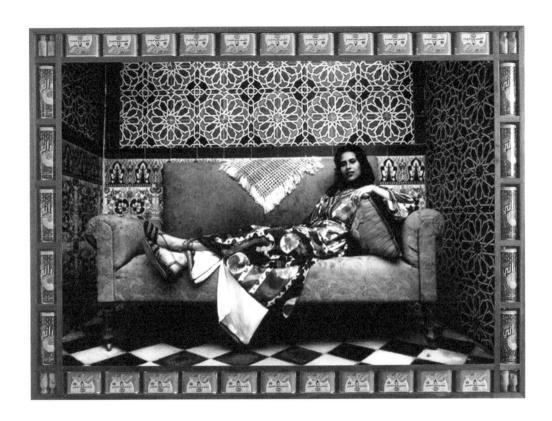

Opposite:
Leonce Raphael Agbodjelou
Untitled (Musclemen series), 2012

Above:
Hassan Hajjaj
Ilham, 2000

23

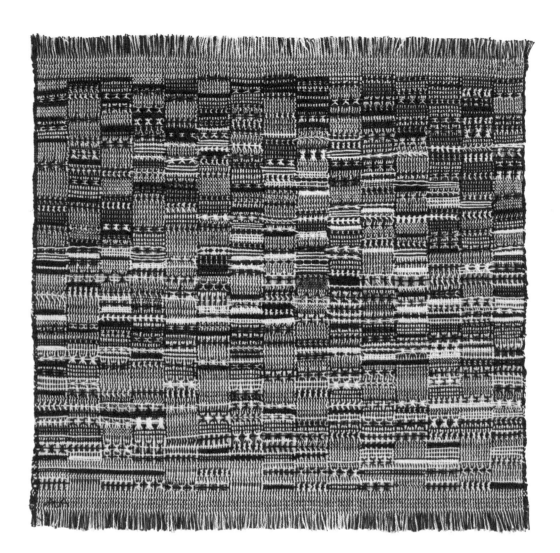

Above:
Anni Albers
Open Letter, 1958

Opposite:
Tasha Amini
Untitled, 2013–15

24

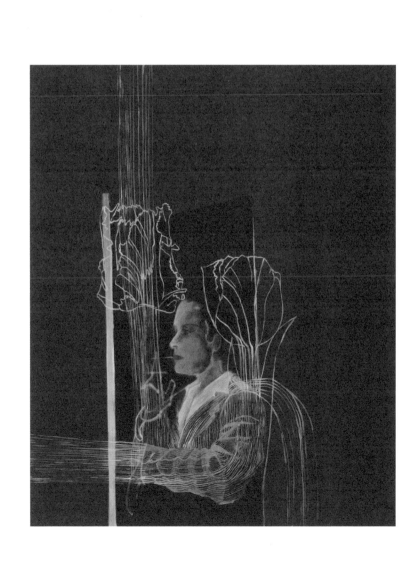

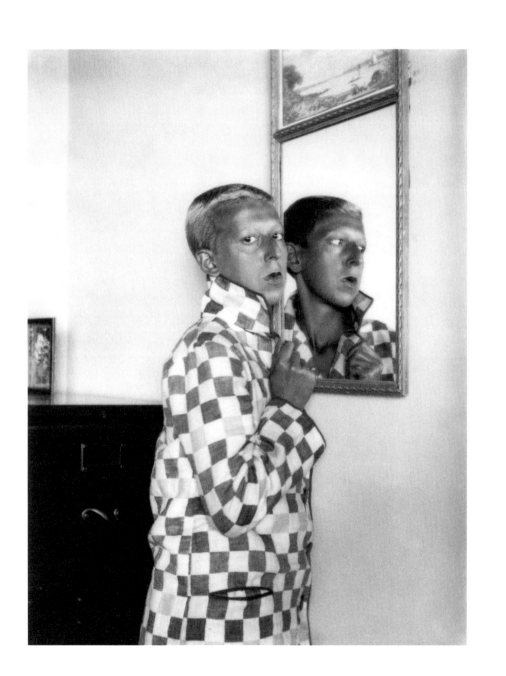

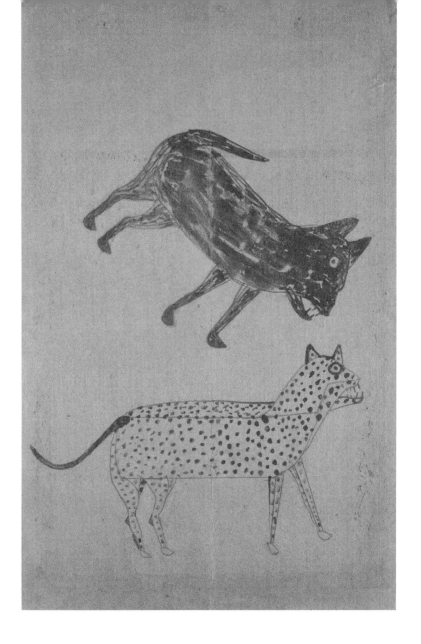

Opposite:
Claude Cahun
*Self Portrait (reflected image in
mirror, chequered jacket)*, 1928

Above:
Bill Traylor
Cat and Dog, c.1939–42

Overleaf:
Donna Huddleston
The Warriors, 2015

27

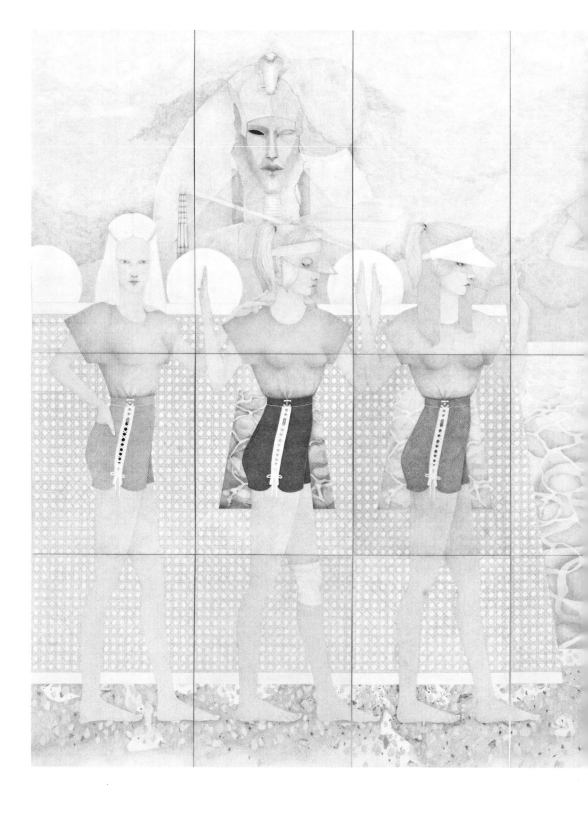

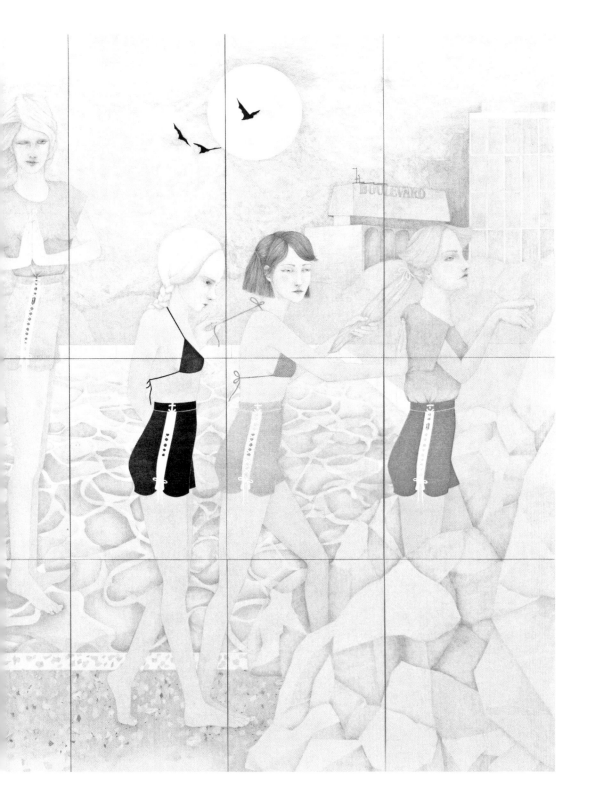

Above:
Alighiero Boetti
Faccine, 1977

Opposite, each:
Hamidou Maiga
Untitled (test print), 1962

30

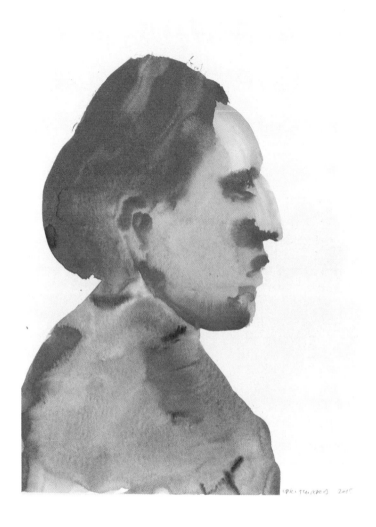

Above:
Francis Upritchard
Untitled, 2015

Opposite:
Zoe Buckman
Hot Like a Toaster, 2015 (detail)

32

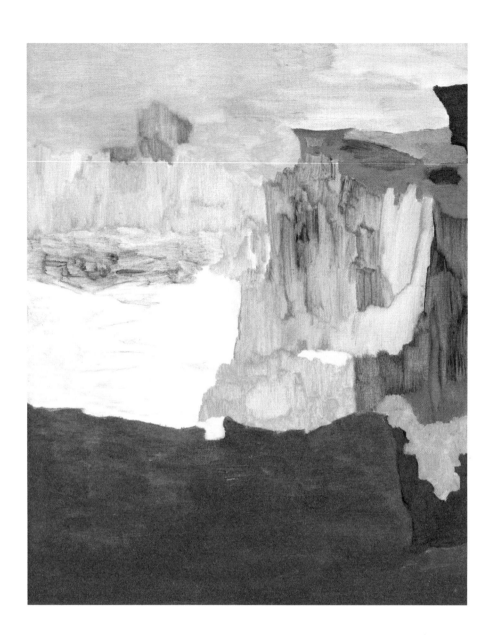

Above:
Andreas Eriksson
Iguassu, 2016

Opposite:
Marina Adams
Wild Blue Yonder, 2015

34

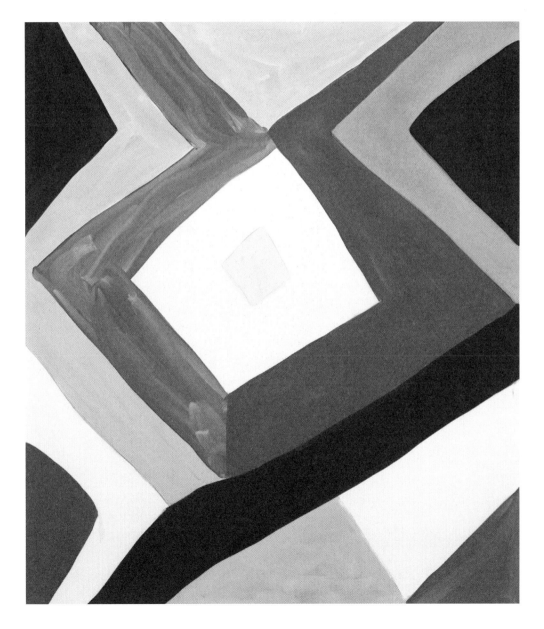

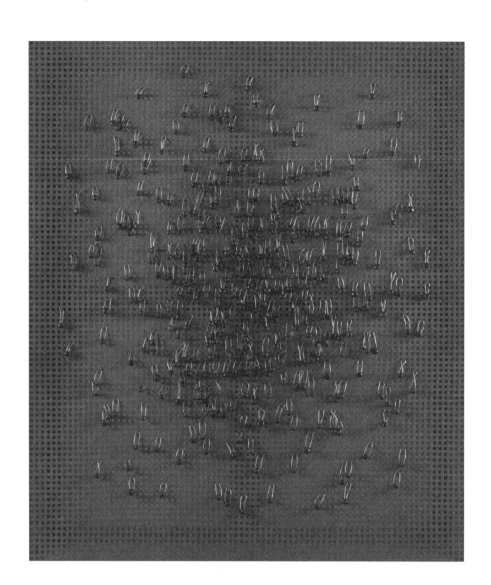

Above:
Daniel Sinsel
Untitled, 2014

Opposite:
Wangechi Mutu
Panties in a Bunch, 2015

36

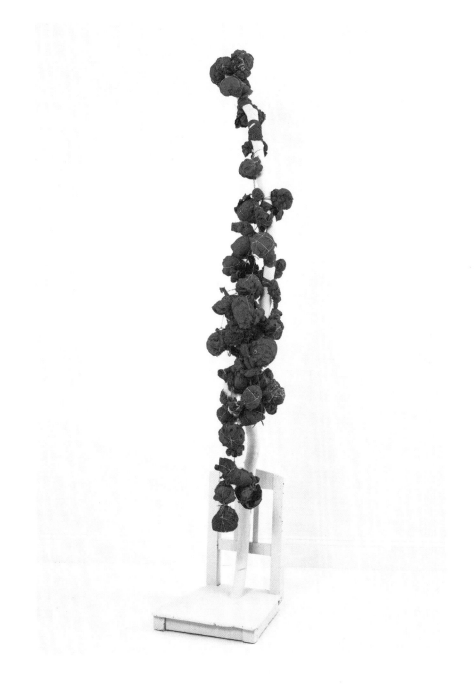

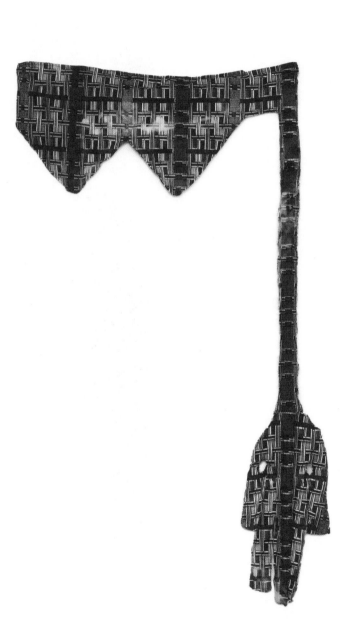

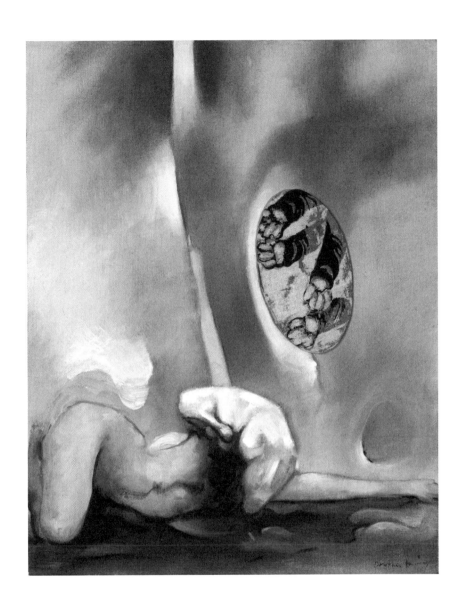

Opposite:
Caroline Achaintre
Lemac, 2015

Above:
Dorothea Tanning
Glad Nude with Paws, 1978

39

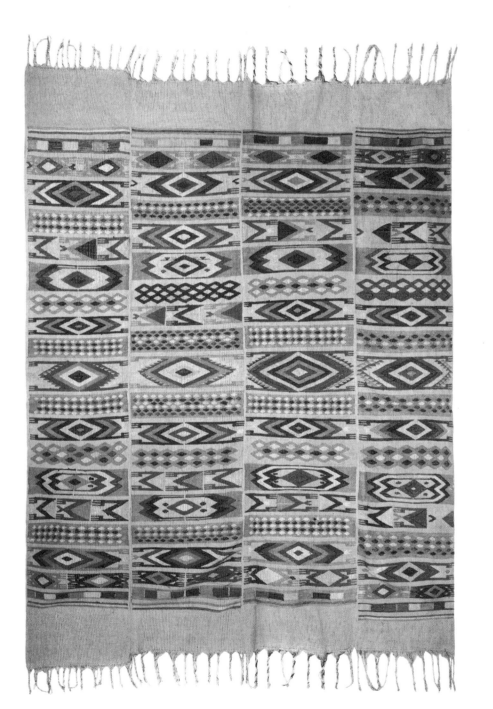

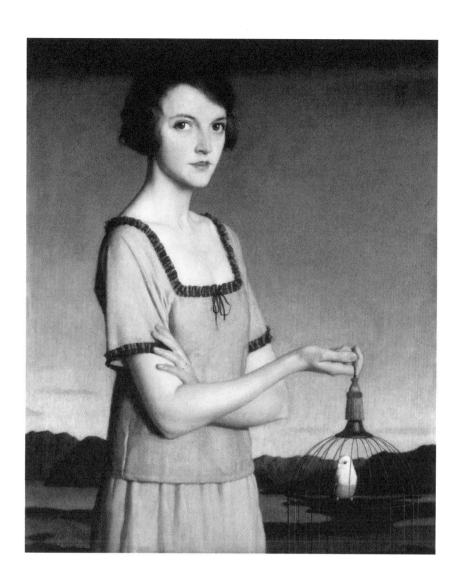

Opposite:
Ijebu Yoruba 'Aso Olona'
woven textile, c.1950

Above:
Meredith Frampton
Winifred Radford, 1921

Overleaf:
Lisa Brice
Untitled, 2016

41

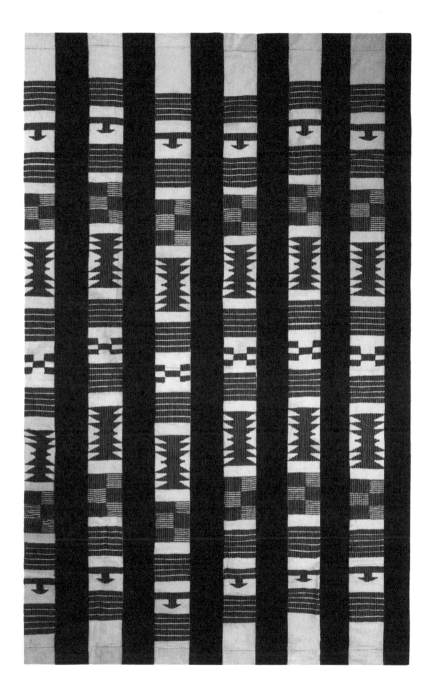

Opposite:
Simon Fujiwara
*Fabulous Beasts (Queens
Premier Ocelot)*, 2015

Above:
Yoruba 'Aso Oke' woven
textile, c.1960

45

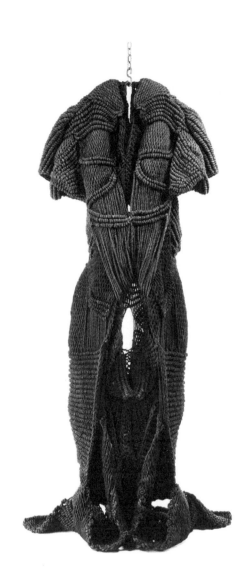

Opposite:
Ibrahim El-Salahi
Untitled, 1965

Above:
Mrinalini Mukherjee
Yakshi, 1984

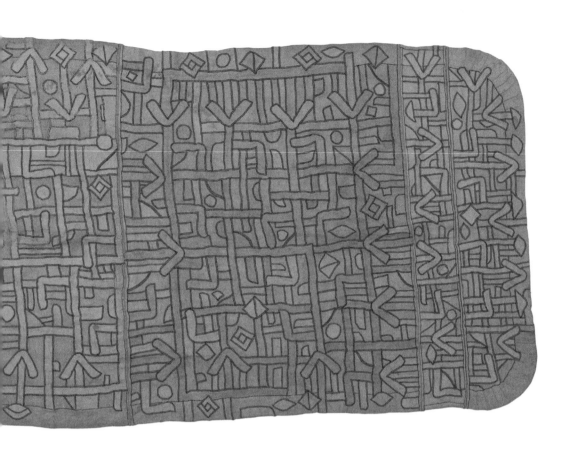

Above:
Kuba textile, Democratic
Republic of Congo, c.late 19th
–early 20th century

Opposite:
Yinka Shonibare MBE
Butterfly Kid (boy) II, 2015

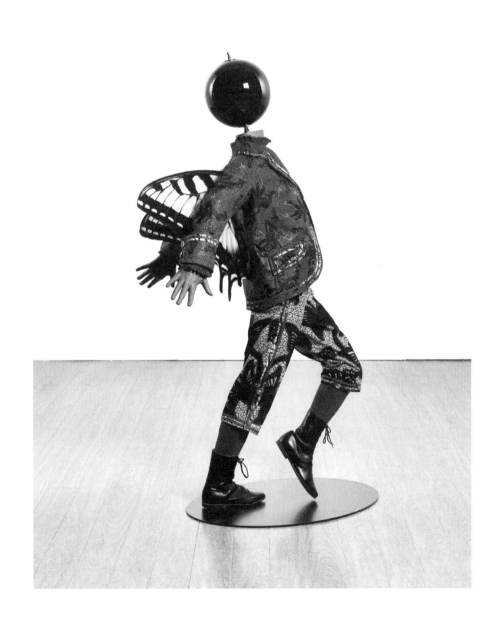

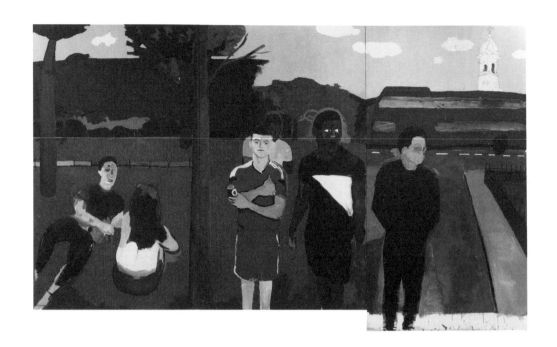

Above:
Henry Taylor
Oscar Murillo's Family, 2015

Opposite:
Tony Armstrong Jones
Jacqui Chan, Venice, 1956

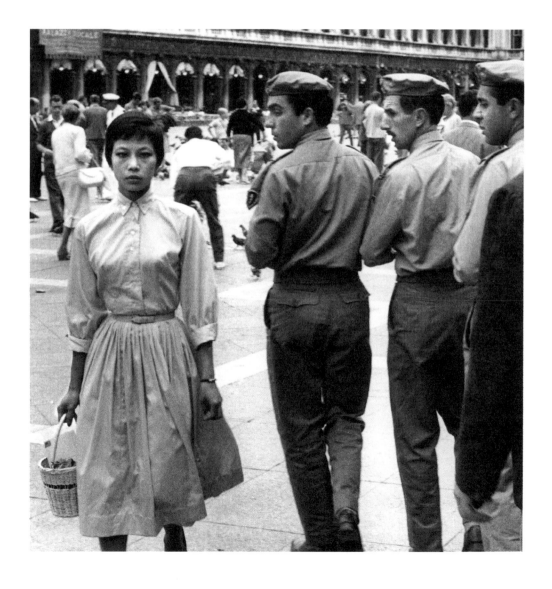

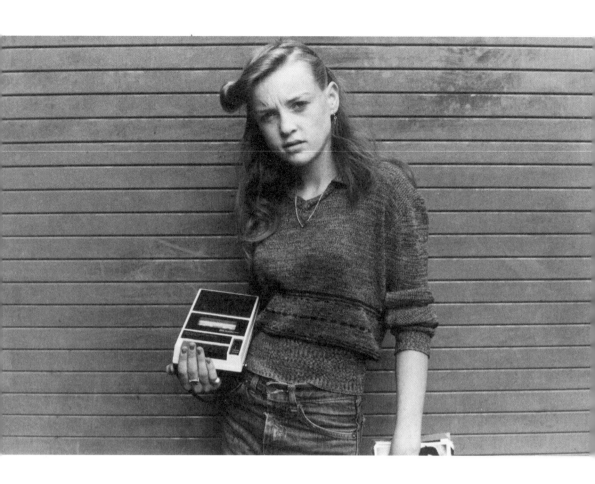

Above:
Al Vandenberg
Untitled, from the
series On a Good Day;
High Street, 1975

Opposite:
Isaac Julien
Before Paradise, 2002

52

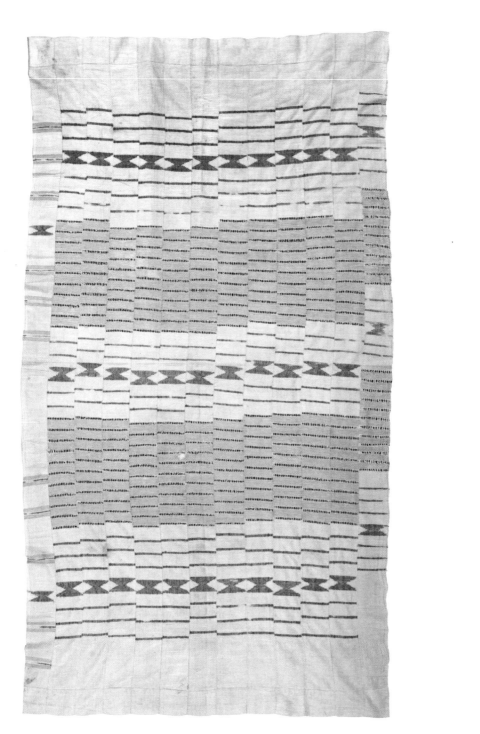

Opposite:
Yoruba 'Aso Oke' woven
textile, late 19th century

Above:
Michael Roberts
SMASH UND GRAB, 2010

Overleaf:
James Brown
Some Neighbors in the Garden of
My Other House, 2013 (detail)

55

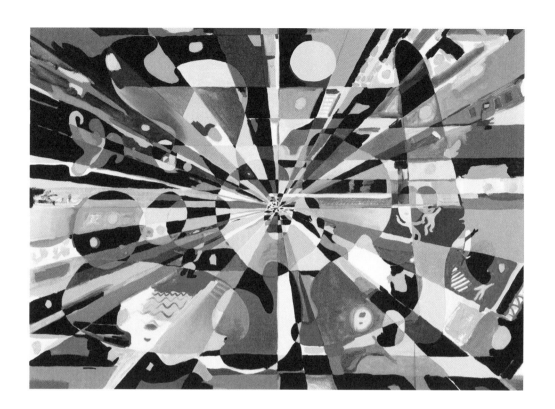

Opposite:
Rodney McMillian
shirt #4, 2009

Above:
Peter McDonald
In the Beat, 2014

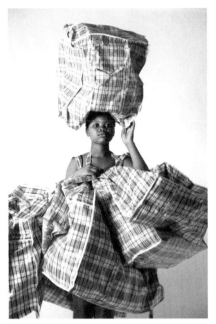

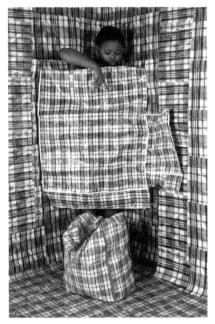
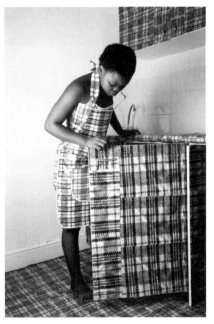

Top to bottom:
Nobukho Nqaba
Untitled #1, 2012
Untitled #2, 2012
Untitled #5, 2012
Untitled #4, 2012
from the series
Umaskhenkethe/Unomgcana

THOUGHTS ON MAKING AND UNMAKING

JENNIFER HIGGIE

Some things never change.

'Life today', wrote Anni Albers in 1938 in the *Black Mountain College Bulletin*, 'is very bewildering. We have no picture of it which is all-inclusive, such as former times may have had.' Her suggested antidote to this modern-day confusion? 'We must', she declared, 'come down to earth from the clouds where we live in vagueness, and experience the most real thing there is: material.'

Materials have their own (often oblique and ever-changing) logic, one that allows for constant rediscovery. When setting out to make something, most artists and designers refuse to predict what the end result might be; the thrill of making lies in the possibility of what might be unearthed, both in the maker and in the materials. Accidents are not always life-threatening; sometimes they give birth to something new. Decoration is functional, in the same way that beauty can be useful – it can calm the mind, soothe the senses and crack open new ways of seeing and, through seeing, a deeper understanding. A respect for, and a profound curiosity about, materials and their imaginative possibilities lies at the heart of all good invention – and good art.

Looking – like life, like time – is never straightforward; neither is creating something new. The character of Antonio, in William Shakespeare's *The Tempest* (1610–11), declares that 'what's past is prologue'. This is apt.

Colour can explode or retreat; dissolve, clash and regroup. Even when seemingly static, it can sing: it's alive! In the same way, a poem can be visual, a painting can be poetic, a dress can be kinetic, and rigid lines can shimmer so hard they seem fluid. The simplest of forms, closely observed, are never predictable. A vessel can be as dazzling, and as secretive, as the blooms that inhabit it. Tommaso Corvi-Mora's ceramics are a case in point.

They're functional, tactile objects, at once original and yet firmly in thrall to pots made by previous generations of makers. Their mix of the prosaic and the poetic makes me think of Gaston Bachelard, who worked as a postman while becoming a philosopher. In one of his most famous books, *La Poétique de l'Espace* (The Poetics of Space, 1957), he wrote: 'Consciousness rejuvenates everything, giving a quality of beginning to the most everyday actions.'

Look closely; as with pots, most things are somehow more than the sum of their parts. The paintings of Marina Adams, for instance, are deceptively simple: colour, shape, line, moving together, separating and then spinning outwards in a trippy geometry. Each form is at once familiar and startling. Similarly, in Donna Huddleston's intricate drawings, a pair of women's shorts is repeated like a mantra; they float, disembodied, above a marbled pool of water. In her monumental frieze, *The Warriors* (2015; pp.28–29), seven young netballers time travel like impudent goddesses in a quasi-theatrical scene in which Sydney and Ancient Egypt appear to be gradually dissolving and re-forming into the same place. The imagination is indifferent to geography and time.

It has, of course, been said many times before that the separation between the stage and life is artificial. We wake, we bathe, we choose the clothes that will see us through the day, the ones that we feel will best express what it is we want to say about ourselves, without saying a word. The only difference between one of Henri Matisse's costumes for the theatre and his paintings of a domestic scene is his choice of medium; the type of play that cloth allows is different to that afforded by paint or paper. But Matisse's sheer joy in his materials was never dimmed. This is true, too, of Yinka Shonibare MBE's sculpture *Bad School Boy* (2014), although his exuberance is perhaps more

complicated. A fibreglass mannequin, Dutch wax-printed cotton textile, a glass flask, resin, a stool, a globe and leather are combined to create a hybrid portrait of a mischievous child: one who manages to express a great sense of life despite the political and social histories related to post-colonialism and globalisation that have created – and, in some ways, attempted to crush – him.

It's a truism that definitions – be they about gender, sexuality, race, politics or art – can be frustratingly (and, of course, at times tragically) restrictive. Take Mrinalini Mukherjee's knotted hemp creations. Mukherjee is known as a fibre artist, but what she created transcends her materials. Her weavings – which are both organic and sci-fi – are psychedelic memorials to complex feelings, evoking strange plants, genitalia, sexual couplings and more. (In a 2000 interview with *India Today,* she said: 'I work intimately with many ideas. It is only later that I get to analyse what I have done.') The fibre artist Diane Itter also created her intimate, beautiful two- and three-dimensional pieces by knotting and weaving brightly dyed thread: she, too, was a time traveller, as inspired by the ancient textile languages of Peru, Japan and the Asante and Ewe people of West Africa as she was by the cultural revolution happening in the United States in the 1960s.

You can't pin any of this down.

Caroline Achaintre – who makes delirious, delicately hued abstract ink drawings and wondrous sculptures from various materials, including fibre and clay – won't be pinned down, either. She has said: 'I'm interested in co-existences – multiple personalities within a being – and in any kind of mask or disguise and its combination of the visor and its bearer.'

The great surrealist photographer, self-portraitist and Second World War hero of the resistance, Claude Cahun, was similarly drawn to the paradoxical idea that the best way to

reveal yourself was with a disguise. She loved mirrors, doubling, make-up and make-believe; in her world, a rock could sprout arms and mannequins had feelings. She famously declared: 'Under this mask, another mask. I will never be finished removing all these faces.' Similarly, Lorna Simpson's collaged works on paper are many things at once: explorations of absurdity, beauty and prejudice; fantastic interpretations of African-American experiences through found images. Space and time here become as deliriously confused as the history of race and representation itself.

Lane Relyea, writing in the catalogue for Polly Apfelbaum's show *What Does Love Have to Do With It* (2003), states that her work is 'both painting and sculpture, and perhaps photography and fashion and formless material process as well. It's all these things – wildly so and wildly not so.' This is a description that could be applied to the work of many of the artists in Duro Olowu's *Making & Unmaking*.

In Beninese photographer Leonce Raphael Agbodjelou's 2012 untitled portraits of young 'musclemen' (p.22), the subjects stand in groups or alone, their toned chests bare, their patterned trousers riotous against the high-pitched colours of the traditional wallpaper and floor coverings of the studio. Their expressions are inscrutable; in their hands they hold, unexpectedly, bunches of plastic flowers. Why? Did the artist ask them to hold the blooms or did the musclemen suggest it themselves? Does the presence of the flowers undermine their machismo or imply an element of tenderness to their strength? This is photography as a form of resistance, one that unequivocally states: never assume anything about anyone.

But we can, on the whole, assume that flowers are happy things. Matisse famously said: 'There are always flowers for those who want to see them.' You don't have to search too hard

for them, here, though: they're everywhere. Wangechi Mutu transforms underpants into a vivid red bunch that buds from a wooden seat; petals decorate the clothing in paintings by Alice Neel and Chris Ofili; Irving Penn focuses his lens on a chicken hat that erupts like a mad flower on a model's head; a smiling young woman stands proudly in front of an arrangement in her living room in a photograph by Neil Kenlock.

As flowers make very clear, everyday objects can be infinitely repurposed. Anni Albers knew this all too well: the world itself was her palette. As well as her weavings, she crafted beautiful necklaces from drain strainers and paper clips, metal seals and bobby pins, aluminium washers and ribbons. The Italian artist, Alighiero Boetti knew it, too. He started out with Arte Povera, the movement that understood that beauty could be born from detritus. He made art from plaster, masonite, plexiglass, light fixtures and other industrial materials before rejecting them for another kind of found object: language itself, numbers, maps and measurements. In Nobukho Nqaba's series of photographs, Umaskhenkethe/Unomgcana (2012; p.60), the artist is seen in an environment crafted solely out of the kind of large plastic bags familiar to anyone moving home or country. Nqaba writes that:

> Unomgcana or Umaskhenkethe is the Xhosa word for the plastic mesh bag, which is made in China. Unomgcana means 'the one with lines' and Umaskhenkethe means 'the traveler'. [...] The bag is a personal reminder of my own migration within South Africa. I have experienced many of the challenges of a migrant and it took me a long time to adjust to life in the places that I have moved to.

Ideas from long ago will always seep into a contemporary consciousness.

The blue hour: the drift of twilight during dawn and dusk when the sun dips below the horizon and its dying rays seem to sigh with melancholy; a moment when estrangement and intimacy go hand in hand and, according to some legends, when people break down and ghosts hover over homes. It's the time of day that gently saturates the surfaces of Lisa Brice's paintings, in which dreamy women perform for themselves and each other. We watch them dressing, undressing, talking, looking or simply gazing out at something or someone we'll never know. They're doing what we all do, but every time, quite despite ourselves, we do it differently. Making and unmaking – it never stops.

Top to bottom:
Horace Ové CBE
Walking Proud, 1970

Neil Kenlock
*Untitled [Young woman seated
on the floor at home in front
of her television set]*, 1972

Overleaf:
Chris Ofili
Untitled (Afromuses), 2005–06

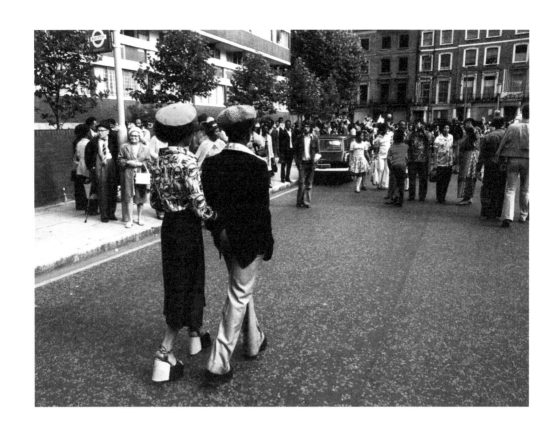

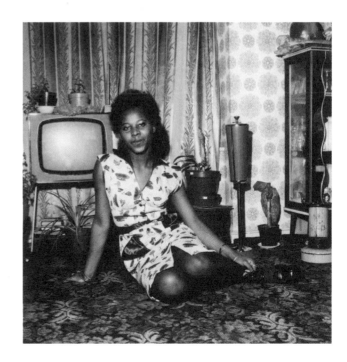

Opposite, top to bottom:
Kehinde Wiley
Saccharum officinarum, 2015
Sterculia chicha, 2015
Abelmoschus esculentus, 2015
Dioscorea cayenensis, 2015

Above:
Alexandre da Cunha
Fortune, 2016

73

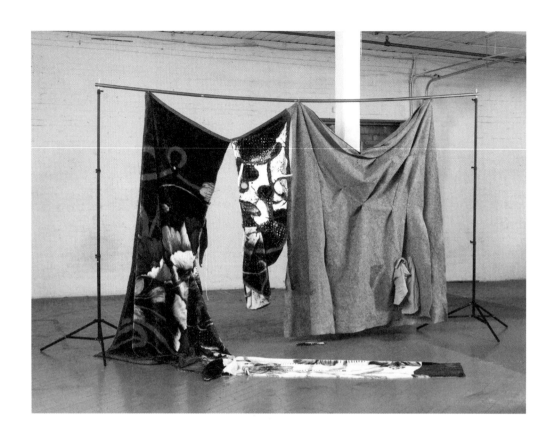

Above:
Eric Mack
In Definitely Felt, 2016

Opposite, top to bottom:
Malick Sidibé
Vues de dos, 2001–08
Vues de dos–Juin, 2003–04
Vues de dos, 2002–04

74

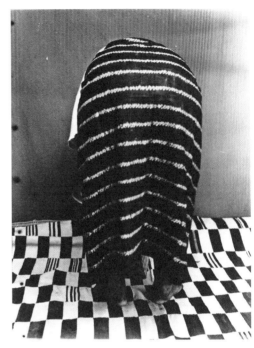

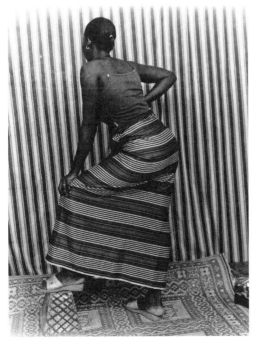

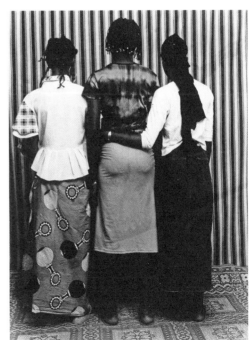

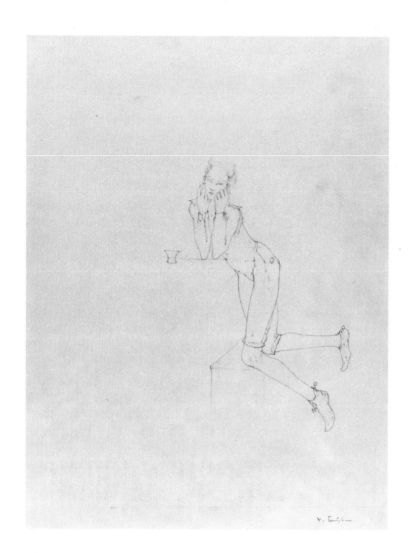

Above:
Christiana Soulou
Figure allégorique/Allegoric Figure, 2011

Opposite:
Brice Marden
Window Study #6, 1985

76

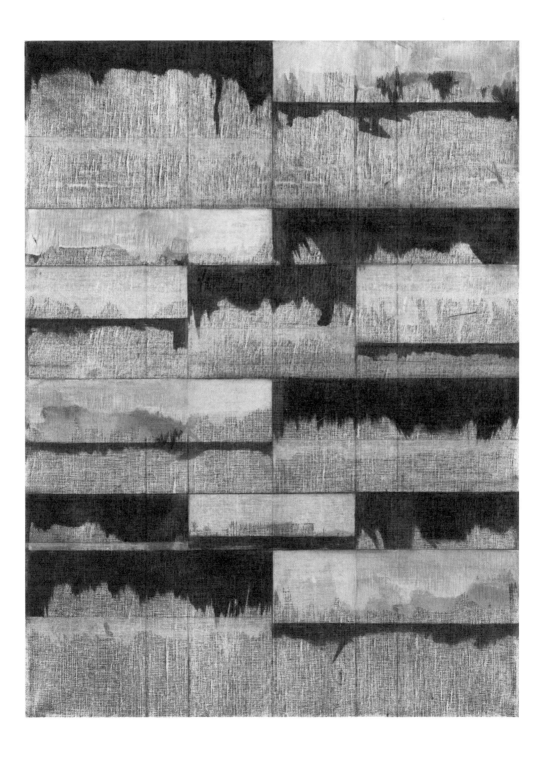

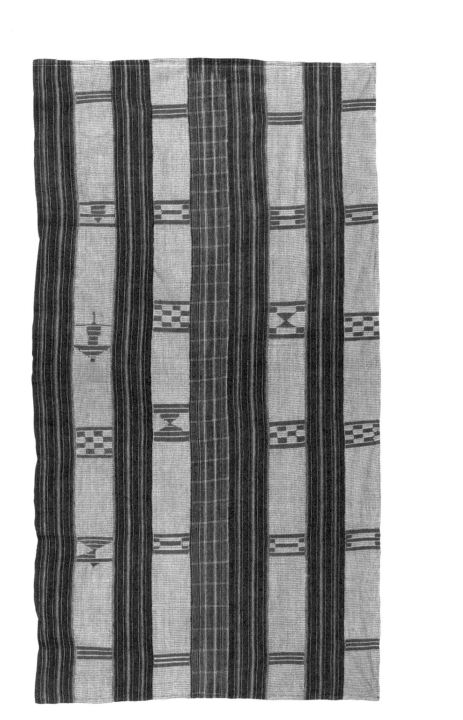

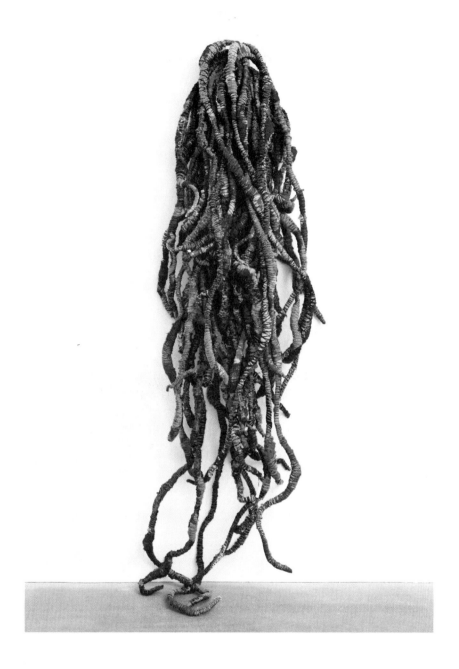

Opposite:
Yoruba 'Aso Oke' woven textile,
late 19th century

Above:
Sheila Hicks
Cordes Sauvages / Hidden Blue, 2014

79

Above, each:
Fernand Léger
Tapis modernes, c.1928

Opposite:
Céline Condorelli
Average Spatial Compositions, 2015

80

Above:
Lygia Clark
Bicho Pássaro do Espaço
(Maquette), 1960

Opposite:
Walead Beshty
Untitled, 2016

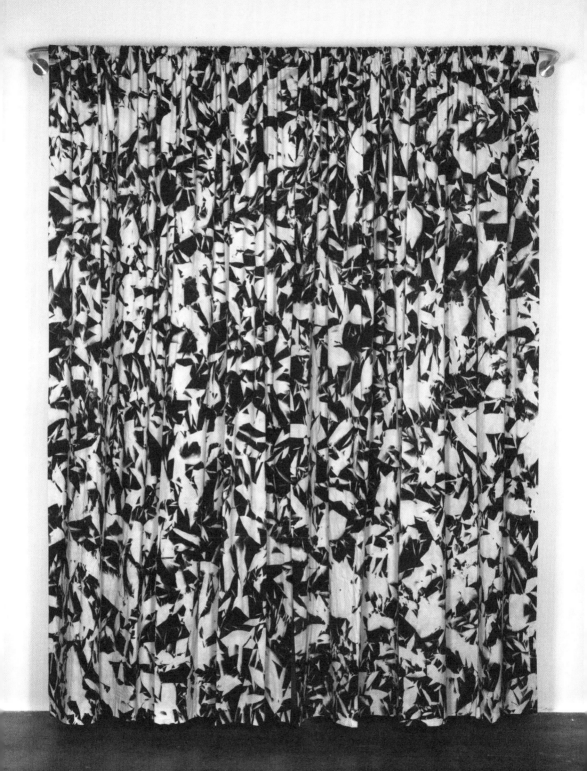

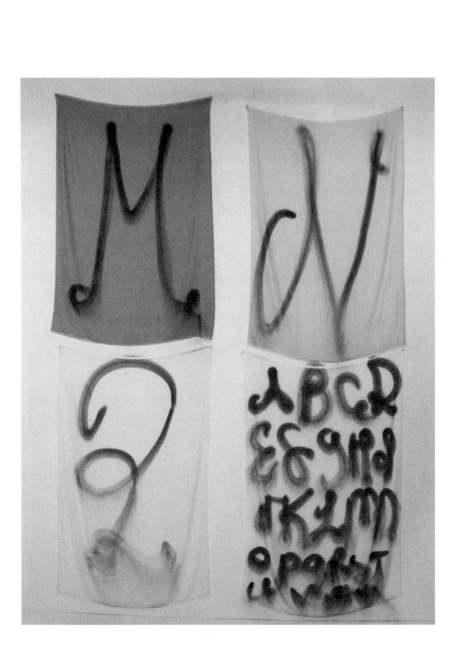

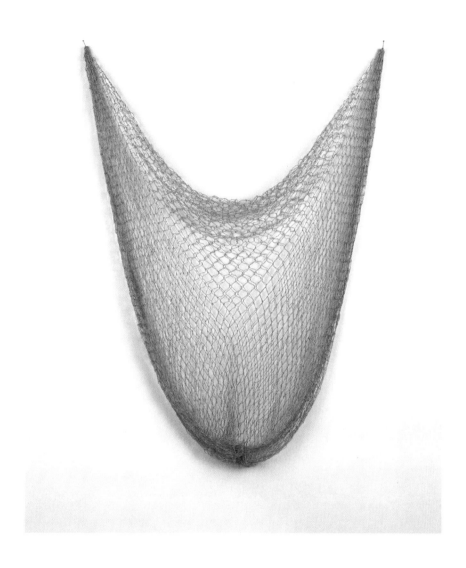

Opposite:
Polly Apfelbaum
Blue Alphabet, 2015 (detail)

Above:
Anya Gallaccio
You got the best of my love, 2007

85

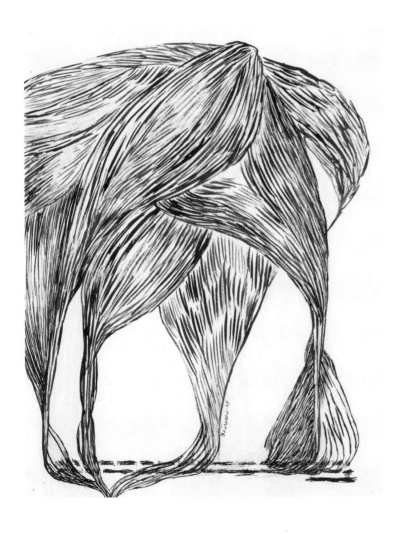

Opposite:
Louise Bourgeois
Untitled, 1949

Above:
Rebecca Ward
stilted, 2015

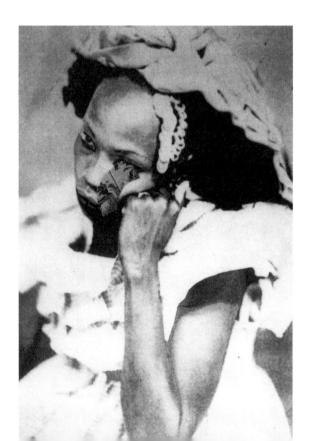

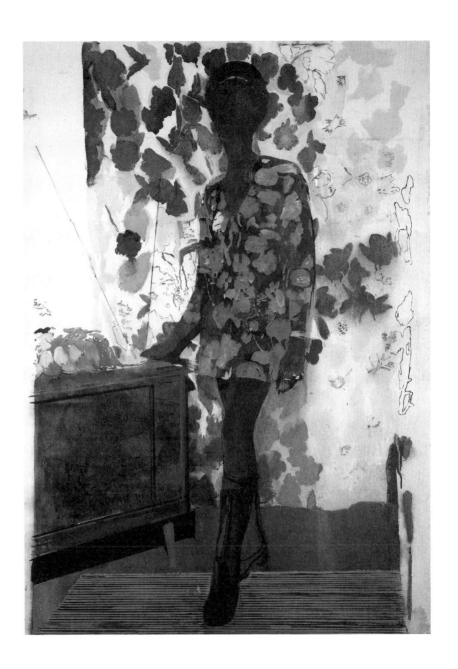

Opposite, top to bottom:
Ari Marcopoulos
B-01, 2015

Grace Wales Bonner
Malik VI, 2015

Above:
Hurvin Anderson
Untitled (Lady/TV), 2001

89

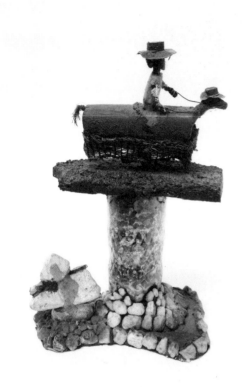

Above:
Emheyo Bahabba (Embah)
Burroquet 1, 2001

Opposite:
Carol Bove
Untitled, 2014

90

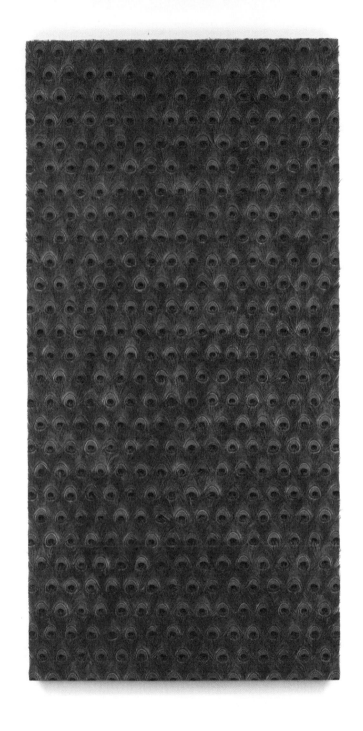

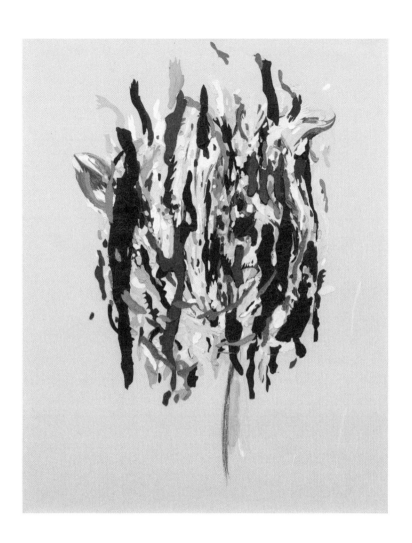

Opposite:
Masaaki Yamada
Work CC25, 1965

Above:
Wardell Milan
A Splendid Flower #1, 2015

Overleaf:
Brent Wadden
DREAMIN' (diptych), 2016

93

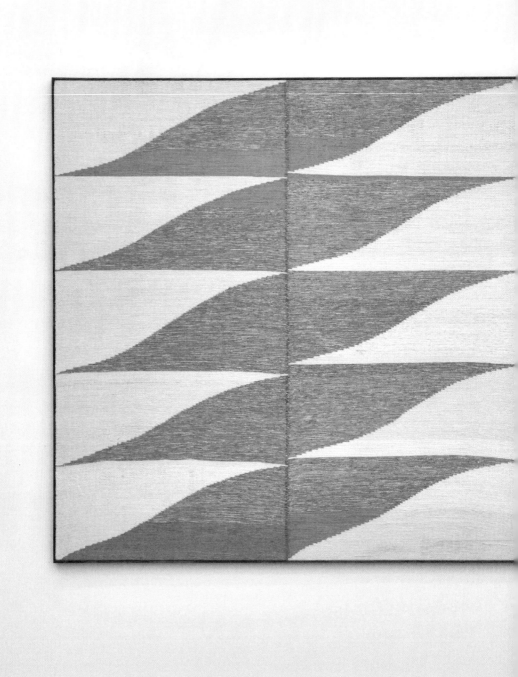

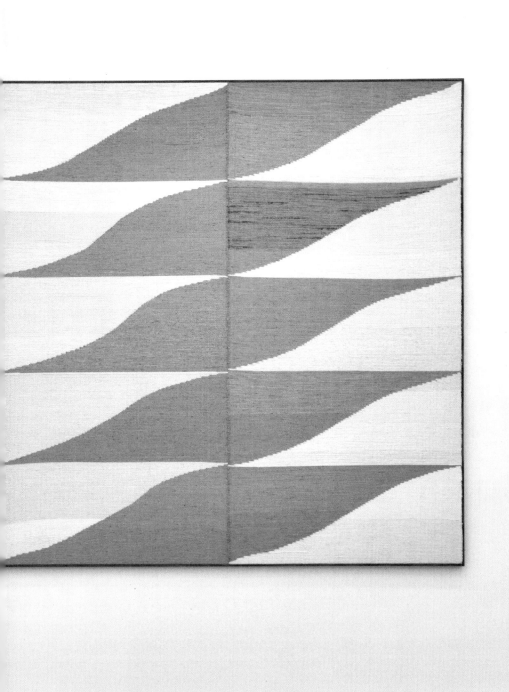

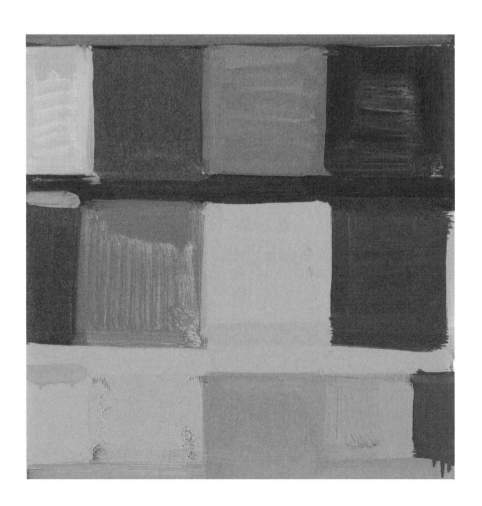

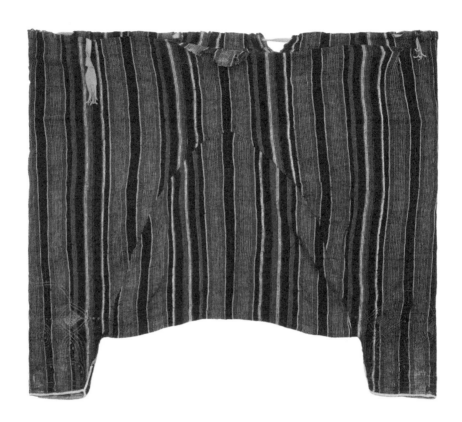

Opposite:
Stanley Whitney
The Blue, 2012

Above:
Yoruba 'Aso Oke' men's
trousers, c.19ᵗʰ century

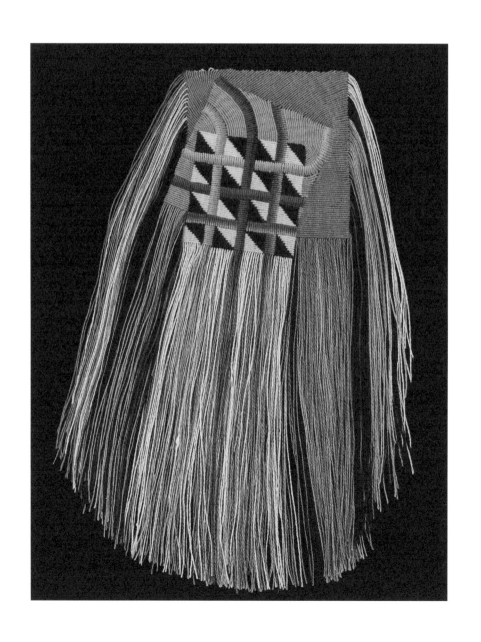

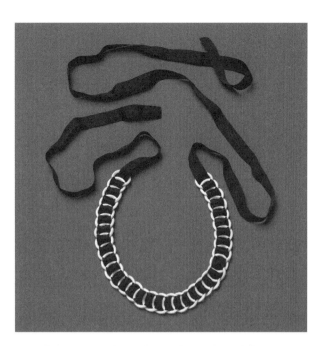

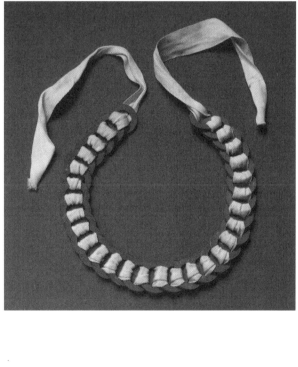

Opposite:
Diane Itter
Floating Bands, 1979

Above, each:
Anni Albers
Necklace, c.1940

99

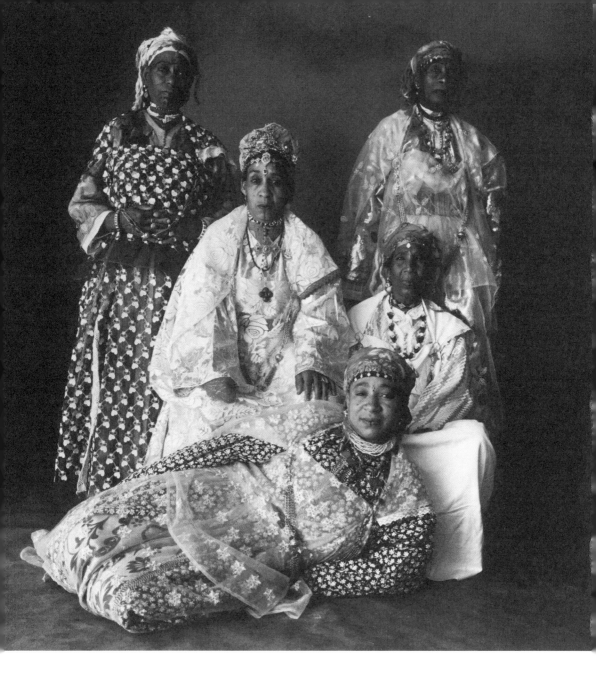

Irving Penn
Five Moroccan Women, 1971

100

THE
PORTRAIT
AND
EMBEDDED
KNOWLEDGE

SHANAY
JHAVERI

Where does Duro Olowu's *Making & Unmaking* stand amongst a crowd of recent exhibitions relating to textiles?[1] It can be wagered at some distance as, by glancing over the list of included artists, it is clear that the exhibition is not a collection of textiles, fabrics and woven structures: it is decidedly non-medium specific in its approach. Here, Olowu appreciates and uncovers the use, place and inscription within various socioeconomic contexts of textiles, while dwelling on their symbolic and affective power. He has gathered together a miscellanea of artworks that are geographically wide-ranging, produced by a group of artistic practitioners in which women, both white and of colour, are well represented. The diversity and inclusivity of the selection is important, in that it speaks to issues of marginalisation that are still so pertinent today. The exhibition underscores this reality through the presentation of those bodies of work whose very production has been shaped by such circumstances. For Olowu, politics of representation actively informs, and is inherent to, his perspective and, by extension, his curatorial selection.

Olowu was born in Lagos and spent his childhood travelling between various European capitals before finally studying law in the United Kingdom. He has recounted that when he was a young boy in the 1970s, he watched his Jamaican mother mixing Yoruba textiles with Yves Saint Laurent Rive Gauche scarves. He recalls how she would 'find tailors who carried sewing machines on their shoulders and get them to make patchwork shirts and furnishings from local fabrics mixed with others she picked up on holidays abroad'.[2] These recollections are telling in what they suggest about Olowu and his approach to fashion, art and textiles. His learned approach of mixing and matching high and low, patching and stitching the homespun and foreign together, sets the tone for his own fashion designs, but also the stage for *Making & Unmaking*. The incorporation of textiles, whether used, worn or

manipulated, allows us to define or discuss the construction of identities, which is a theme that underpins the exhibition.

The inclusion of textiles in the portraits within the exhibition–in the form of painting, drawing, sculpture and photography–helps to convey the impact lived experiences have on the formation of their identities. Horace Ové CBE's *Walking Proud* (1970; p.69), for instance, draws attention to Britain's relationship to race both past and present, as the subjects proudly and self-confidently assert their place and presence in Britain through their style and posture. Shifting to the contemporary, Hassan Hajjaj's *Ilham* (2000; p.23) and Leonce Raphael Agbodjelou's Musclemen series (2012; p.22) challenge identity and gender within the structure of portraiture. In *Ilham*, Hajjaj plays with a classical art-historical subject and composition: a female figure reclining on a sofa, her gaze directly engaging with the camera to invite the spectator in. Agbodjelou, meanwhile, showcases toned shirtless men from the Republic of Benin, wearing colourful trousers and holding bouquets of plastic flowers against elaborately patterned backdrops. In each of their staged tableaus, Hajjaj's and Agbodjelou's uses of textiles, décor and accessories contest established notions about body, gender, race and class. Moreover, Lorna Simpson's most recent collages–such as *Cliff* (2016; p.20), which places an image of a female face on a sliced-up animal body–remind us that identity can endlessly be performed as well as the crucial role that ornament and dress can play in this process. Simpson's portraits reveal the complexity that self-fashioning allows, which is a notion that many of the artists in the exhibition confront.

Olowu has also selected a group of lesser-known studio portraits of veiled Moroccan women by Irving Penn, such as *Five Moroccan Women* (1971; p.100), which take on a different charge when viewed alongside Malick Sidibé's more recent

103

Vues de dos photographs (2001–08; p.75). In Sidibé's work the female subjects retain their privacy, by turning away from the camera and obstructing their faces, while in Penn's *Five Moroccan Women* the female is seen in her entirety, but remains equally unknowable. Both sets of photographs are in part determined by the prevailing ideas of beauty and gender in their respective countries and eras, yet the subjects' awareness of an artist's gaze affects how they chose to present and position their bodies.

Through painting and drawing, Lisa Brice's women also represent this notion of presentation and observation, albeit within a different context. Rendered in various states of undress, their bodies in partial and full view, these are women who are grooming themselves, scrutinising their reflections in a mirror, mostly within the confines of what appear to be domestic spaces. Alongside Brice's directly communicative portraits, Olowu mixes in a selection of Lynette Yiadom-Boakye's paintings, whose subjects do not provide any clues to a time period, location or place. The simplicity and intensity of Yiadom-Boakye's subjects divulge her real concern: the act of painting, and how representations of these individuals are constructed. By meditating on how a persona is made Yiadom-Boakye's paintings cut straight to the heart of the matter that Olowu explores in the exhibition. The works ask: How do we make ourselves for ourselves and others? How do we unmake ourselves for ourselves and others?

Olowu's own personal process is reflected in *Making & Unmaking*, operating from a position of acquired and assumed knowledge that has guided his choice of objects. His cosmopolitan sensibility is one that is very much tethered to a particular context, but simultaneously challenges set categories of geography and history through reconfiguring and refashioning relations between the local and international,

or the past and present. As the art historian Donna Haraway articulates, knowledge is embedded within a context – be it anthropological, intellectual or cultural.[3] By responding to the context in which that point of view is formed, Olowu's selection accrues depth and meaning. His position permits a connection to these artists that operates from a particular point of view: a recognition and, to a certain extent, celebration of a shared experience that has the potential to affect alternative ways of understanding. Through a diverse selection of artists, works and media, Olowu enthusiastically embraces this sense of freedom in *Making & Unmaking*.

[1] To name only a few: *The Stuff That Matters* (2012) at London's Raven Row, where famed textile collector Seth Siegelaub's collection was on display; *Fracture: Indian Textiles, New Conversations* (2015) mounted by the Devi Art Foundation in New Delhi, in which South Asian artists and fashion designers collaborated with local artisans and craftspeople to produce new commissions; or Grant Watson and Rike Frank's *Textiles: Open Letter* (2013) at Museum Abteiberg in Mönchengladbach, where textiles were situated 'between applied and "free" artistic practice, between craft and art.'

[2] Duro Olowu to Suzy Menkes, 'My Lagos: Duro Olowu's Home Town', *The New York Times*, 14 November 2012, accessed 19 April 2016.

[3] Haraway passionately declares that she is 'arguing for politics and epistemologies of location, positioning, and situating where partiality and not universality is the condition of being heard to make rational knowledge claims. [...] I am arguing for the view from a body, always a complex, contradictory structuring and structured body.' Donna Haraway, 'Situated Knowledges: The Science Question in Feminism and the Privilege of Partial Perspective', *Feminist Studies*, vol.14, no.3, autumn, 1988, p.589.

List of Plates

p.35
Marina Adams
Wild Blue Yonder, 2015
Acrylic on linen
198 × 173 cm
78 × 68⅛ in

p.36
Daniel Sinsel
Untitled, 2014
Oil on handwoven linen support,
hazelnut shells, limewood stretcher
150 × 130 × 12 cm
59⅛ × 51⅛ × 4⅜ in

p.37
Wangechi Mutu
Panties in a Bunch, 2015
Wooden seat, lingerie
226.1 × 43.2 × 40.6 cm
89⅛ × 17⅛ × 16 in

p.38
Caroline Achaintre
Lemac, 2015
Fabric
169 × 97 × 7 cm
66½ × 38¼ × 2⅜ in

p.39
Dorothea Tanning
Glad Nude with Paws, 1978
Oil on canvas with fabric collage
50.8 × 40.3 cm
20 × 15⅞ in
The Destina Foundation,
New York

p.40
Ijebu Yoruba 'Aso Olona'
woven textile, c.1950
Cotton, rayon
220 × 163 cm
86⅝ × 64⅛ in
Collection of Duro Olowu

p.41
Meredith Frampton
Winifred Radford, 1921
Oil on canvas
89.2 × 74.6 cm
35⅛ × 29⅜ in
National Portrait Gallery, London
Purchased, 1997

pp.42–43
Lisa Brice
Untitled, 2016
Gesso, synthetic tempera
and ink on canvas
184 × 244 cm
72½ × 96⅛ in

p.44
Simon Fujiwara
Fabulous Beasts (Queens Premier Ocelot), 2015
Shaved fur coat
145 × 90 × 2 cm
57⅛ × 35⅜ × ⅜ in
David Roberts Collection, London

p.45
Yoruba 'Aso Oke' woven textile,
c.1960
Cotton, silk
182 × 120 cm
71⅝ × 47¼ in
Collection of Duro Olowu

p.46
Ibrahim El-Salahi
Untitled, 1965
Etching on paper
23 × 32 cm
9⅛ × 12⅝ in

p.47
Mrinalini Mukherjee
Yakshi, 1984
Hemp fibre
225 × 105 × 72 cm
88⅝ × 41⅜ × 28⅜ in
Private collection, UK

p.48 & cover (modified)
Kuba textile, Democratic
Republic of Congo, c.late 19th–
early 20th century
Handwoven raffia with
sewn appliqué
Collection of Okwui Enwezor,
Munich

p.49
Yinka Shonibare MBE
Butterfly Kid (boy) II, 2015
Fibreglass mannequin, Dutch
wax-printed cotton, silk, metal,

globe, leather, steel baseplate
134 × 66 × 86 cm
52⅜ × 26 × 33⅞ in
British Council Collection

p.50
Henry Taylor
Oscar Murillo's Family, 2015
Acrylic on canvas
295.5 × 490.5 cm
116⅜ × 193⅛ in

p.51
Tony Armstrong Jones
Jacqui Chan, Venice, 1956
Bromide print
45.5 × 45.5 cm
17⅞ × 17⅞ in

p.52
Al Vandenberg
Untitled, from the series
On a Good Day; High Street, 1975
Gelatin-silver print
12.5 × 19.3 cm
4⅝ × 7⅝ in
Victoria & Albert Museum,
London. Purchased through
the Cecil Beaton Fund

p.53
Isaac Julien
Before Paradise, 2002
Pigment ink print
Three panels
Each: 100 × 100 cm
39⅜ × 39⅜ in

p.54
Yoruba 'Aso Oke' woven textile,
late 19th century
Cotton, silk
196 × 107 cm
77⅛ × 42⅛ in

p.55
Michael Roberts
SMASH UND GRAB, 2010
Mixed media collage on foam
board; pencil sketch of Alber
Elbaz on the verso
64.4 × 50 cm
25⅜ × 19¾ in
Private collection

p.56–57
James Brown
Some Neighbors in the Garden of My Other House, 2013 (detail)
Collage, paint and pencil on vintage linen
1.1 × 12 m
4 × 29 ft

p.58
Rodney McMillian
shirt #4, 2009
Re-purposed shirts, fabric, thread; photographed on body
Dimensions variable

p.59
Peter McDonald
In the Beat, 2014
Acrylic on canvas
81 × 114 cm
31 $^7/_8$ × 44 $^7/_8$ in

p.60 (top to bottom)
Nobukho Nqaba
Untitled #1, 2012
Untitled #2, 2012
Untitled #5, 2012
Untitled #4, 2012
from the series Umaskhenkethe/Unomgcana
C-type prints
Each: 70 × 50 cm
27 $^1/_2$ × 19 $^3/_8$ in
African Artists' Foundation

p.69 (top)
Horace Ové CBE
Walking Proud, 1970
C-type print
78.5 × 104 cm (framed)
30 $^7/_8$ × 41 in

p.69 (bottom)
Neil Kenlock
Untitled [Young woman seated on the floor at home in front of her television set], 1972
C-type print
34.6 × 34.8 cm
13 $^5/_8$ × 13 $^3/_8$ in
Victoria & Albert Museum, London. Supported by the National Lottery through the Heritage Lottery Fund

pp.70–71
Chris Ofili
Untitled (Afromuses), 2005–06
Watercolour and pencil on paper
Two panels
Each: 48.2 × 32.4 cm
19 × 12 $^3/_4$ in
Private collection

p.72 (top to bottom)
Kehinde Wiley
Saccharum officinarum, 2015
Sterculia chicha, 2015
Abelmoschus esculentus, 2015
Dioscorea cayenensis, 2015
Watercolor on paper
Each: 40.6 x 30.5 cm
16 × 12 $^1/_8$ in
Bottom right: 35.6 x 27.9 cm
14 $^1/_8$ x 11 in

p.73
Alexandre da Cunha
Fortune, 2016
Fur gloves, linen
80 × 80 × 3 cm
31 $^1/_2$ × 31 $^1/_2$ × 1 $^1/_8$ in

p.74
Eric Mack
In Definitely Felt, 2016
Acrylic on polyester plush blanket, polyfibre shipping blanket, pins, cotton, felt and rope on metal armature
2.4 × 4.9 × 2.3 m
8 × 16 × 7 $^1/_2$ ft

p.75 (top to bottom)
Malick Sidibé
Vues de dos, 2001–08
Vues de dos – Juin, 2003–04
Vues de dos, 2002–04
Gelatin-silver prints
Each: 37.5 × 27.6 cm
14 $^3/_8$ × 10 $^7/_8$ in

p.76
Christiana Soulou
Figure allégorique/Allegoric Figure, 2011
Pencil on paper
66.5 × 51 cm
26 $^1/_8$ × 20 $^1/_8$ in

p.77
Brice Marden
Window Study #6, 1985
Oil on linen
61 × 46 cm
24 $^1/_8$ × 18 $^1/_8$ in
Private collection

p.78
Yoruba 'Aso Oke' woven textile, late 19th century
Cotton, silk
195 × 108 cm
76 $^3/_8$ × 42 $^1/_2$ in

p.79
Sheila Hicks
Cordes Sauvages/Hidden Blue, 2014
Cotton, wool, linen, silk, bamboo, synthetic
250 × 70 × 70 cm
98 $^3/_8$ × 27 $^1/_2$ × 27 $^1/_2$ in
Deighton Collection

p.80 (each)
Fernand Léger
Tapis modernes, c.1928
Éditions H Ernst, Paris
Stencilled plate on laminated paper
Top: 12.3 × 20.7 cm
4 $^7/_8$ × 8 $^1/_8$ in
Bottom: 11.5 × 20.8 cm
4 $^1/_2$ × 8 $^1/_4$ in

p.81
Céline Condorelli
Average Spatial Compositions, 2015
Mild steel, plywood, upholstery, fabric, paint
Dimensions variable

p.82
Lygia Clark
Bicho Pássaro do Espaço (Maquette), 1960
Aluminium
24.3 × 24.1 × 0.9 cm
9 $^5/_8$ × 9 $^1/_2$ × $^3/_8$ in

p.83
Walead Beshty
Untitled, 2016
Cyanotype on linen
Dimensions variable

p.84
Polly Apfelbaum
Blue Alphabet, 2015 (detail)
Spray paint on synthetic silk rayon
27 sections
Each: 142×91.5 cm
55⁷/₈ × 36¹/₈ in

p.85
Anya Gallaccio
You got the best of my love, 2007
Fishing net in gold lamé thread
87×59 cm
34¹/₄ × 23¹/₄ in

p.86
Louise Bourgeois
Untitled, 1949
Ink on paper
35.6×27.9 cm
14¹/₈ × 11 in
Private collection

p.87
Rebecca Ward
stilted, 2015
Oil and acrylic on stitched canvas
81.3×61 cm
32¹/₈ × 24¹/₈ in

p.88 (top)
Ari Marcopoulos
B-01, 2015
Inkjet print on rice paper
27.9×21.6 cm
11 × 8¹/₂ in

p.88 (bottom)
Grace Wales Bonner
Malik VI, 2015
Collage on paper
29.2×19.4 cm
11¹/₂ × 7⁵/₈ in

p.89
Hurvin Anderson
Untitled (Lady/TV), 2001
Oil on canvas
140×100 cm
55¹/₈ × 39³/₈ in
Collection Martine d'Anglejan-
Chatillon and Dara Khera

p.90
Emheyo Bahabba (Embah)
Burroquet 1, 2001
Wood, stone, plastic, glass, sand,
plaster, string, cardboard, resin,
wood glue, oil and enamel paint
33×16×22 cm
13 × 6¹/₂ × 8⁵/₈ in
Private collection

p.91
Carol Bove
Untitled, 2014
Peacock feathers on linen,
UV filtering acrylic
245.1×123.2×12.7 cm
96¹/₂ × 48¹/₂ × 5 in

p.92
Masaaki Yamada
Work CC25, 1965
Oil on canvas
45×38 cm
17³/₄ × 15 in

p.93
Wardell Milan
A Splendid Flower #1, 2015
Charcoal and oil on canvas
76.2×61 cm
30 × 24¹/₈ in

pp.94–95
Brent Wadden
DREAMIN' (diptych), 2016
Handwoven fibres, wool,
cotton and acrylic on canvas
Two panels
Overall: 227×454 cm
89³/₈ × 178³/₈ in

p.96
Stanley Whitney
The Blue, 2012
Oil on linen
51×51 cm
20¹/₈ × 20¹/₈ in
Private collection

p.97
Yoruba 'Aso Oke' men's trousers,
c.19ᵗʰ century
Cotton, silk

102×90 cm
40¹/₈ × 35³/₈ in
Collection of Duro Olowu

p.98
Diane Itter
Floating Bands, 1979
Knotted linen
30.5×27.9 cm
12 × 11 in
Sue and Malcolm Knapp

p.99 (top)
Anni Albers
Necklace, c.1940
Plastic rings, grosgrain ribbon
Length: 149.2 cm
58³/₈ in
Josef and Anni Albers Foundation

p.99 (bottom)
Anni Albers
Necklace, c.1940
Rubber rings, grosgrain ribbon
Length: 86 cm
34 in
Josef and Anni Albers Foundation

p.100
Irving Penn
Five Moroccan Women, 1971
Platinum-palladium print
5.1×5 cm
2¹/₈ × 2 in
Victoria & Albert Museum,
London

Dust jacket (inner)
Silkscreen printed textile, c.1972
(detail)
Cotton brocade
120×180 cm
47¹/₄ × 70⁷/₈ in
Collection of Duro Olowu

Credits

Courtesy Corvi-Mora, London and Jack Shainman Gallery, New York: p.17

Courtesy Corvi-Mora, London: p.18 (top)

©Tal R. Courtesy of Contemporary Fine Arts, Berlin: p.18 (bottom)

©The Estate of Alice Neel. Courtesy the artist's estate and Victoria Miro, London: p.19

Courtesy of the artist and Salon 94, New York: p.20

Courtesy of the Jersey Heritage Collections: pp.21, 26

©Leonce Raphael Agbodjelou. Courtesy of Jack Bell Gallery, London: p.22

©Hassan Hajjaj. Courtesy of Rose Issa Projects: p.23

©2016 Josef and Anni Albers Foundation/DACS: pp.24, 99

©Tasha Amini. Courtesy of the artist: p.25

©Estate of Bill Traylor. Courtesy of Michael Rosenfeld Gallery LLC, New York: p.27

Courtesy of the artist: pp.28–29

©DACS 2016: p.30

©Hamidou Maiga. Courtesy of Jack Bell Gallery, London: p.31

Courtesy of the artist and Kate MacGarry, London: p.32

Courtesy the artist and Bethanie Brady Artist Management: p.33

©DACS 2016. Courtesy the artist and Stephen Friedman Gallery, London: p.34

Courtesy of Salon 94, New York: p.35

©Daniel Sinsel. Courtesy of Sadie Coles HQ, London: p.36

©Wangechi Mutu. Courtesy the artist and Victoria Miro, London: p.37

©Caroline Achaintre. Courtesy of Arcade, London: p.38

©DACS, London/ADAGP, Paris. Courtesy of The Destina Foundation, New York and Alison Jacques Gallery, London: p. 39

Courtesy of Duro Olowu: pp.40, 45, 97, dust jacket (inner)

©National Portrait Gallery, London: p.41

©Lisa Brice. Courtesy of the artist: pp.42–43

©Simon Fujiwara. Courtesy of the artist and Laura Bartlett Gallery, London: p.44

©Ibrahim El-Salahi. All rights reserved, DACS 2016. Courtesy of Vigo Gallery and the artist: p.46

©Estate of Mrinalini Mukherjee. Courtesy Jhaveri Contemporary: p.47

©Yinka Shonibare MBE. All Rights Reserved, DACS 2016. Courtesy Yinka Shonibare MBE and Stephen Friedman Gallery, London: p.49

©The artist. Courtesy Blum & Poe, Los Angeles and Carlos/Ishikawa, London: p.50

©Armstrong Jones: p.51

©Al Vandenberg/Victoria and Albert Museum, London: p.52

©Isaac Julien. Courtesy the artist and Victoria Miro, London: p.53

Courtesy of Duncan Clarke, Adire African Textiles: pp.54, 78

©Michael Roberts: p.55

©ADAGP, Paris and DACS, London 2016. Courtesy of the artist: pp.56–57

Courtesy of the artist: p.58

Courtesy of the artist and Kate MacGarry, London: p.59

Courtesy of African Artists' Foundation: p.60

©Horace Ové CBE: p.69 (top)

©Neil Kenlock 2016. All rights reserved/Victoria and Albert Museum, London: p.69 (bottom)

©Chris Ofili: pp.70–71

©Kehinde Wiley. Courtesy the artist and Stephen Friedman Gallery, London: p.72

©Alexandre da Cunha. Courtesy of the artist and Thomas Dane Gallery, London: p.73

Courtesy of the artist and Moran Bondaroff, Los Angeles: p.74

©Malick Sidibé. Courtesy of the artist and Jack Shainman Gallery, New York: p.75

©Christiana Soulou. Courtesy Sadie Coles HQ, London: p.76

©ARS, NY and DACS, London 2016. Courtesy private collection: p.77

©Sheila Hicks. Courtesy of Deighton Collection and Alison Jacques Gallery, London: p. 79

©ADAGP, Paris and DACS, London 2016. Courtesy Matthew Foster, Art Deco Gallery, London: p.80

©Céline Condorelli. Courtesy of the artist: p.81

©O Mundo de Lygia Clark-Associação Cultural, Rio de Janeiro. Courtesy of Alison Jacques Gallery, London: p. 82

©Walead Beshty. Courtesy of the artist and Thomas Dane Gallery, London: p.83

Courtesy the artist and Frith Street Gallery, London: p.84

©Anya Gallaccio. Courtesy of the artist and Thomas Dane Gallery, London: p.85

©The Easton Foundation/VAGA, New York/DACS, London 2016: p.86

Courtesy the artist and Luxembourg & Dayan, New York: p.87

Courtesy Marlborough Chelsea, New York: p.88 (top)

©Grace Wales Bonner: p.88 (bottom)

©Hurvin Anderson. Courtesy of the artist and Thomas Dane Gallery, London: p.89

Courtesy private collection: p.90

Courtesy the artist, Maccarone, New York/Los Angeles and David Zwirner, New York/London: p.91

Courtesy of Vigo Gallery and the artist: p.92

©Wardell Milan. Courtesy David Nolan Gallery, New York: p.93

©Brent Wadden 2016. Courtesy

110

of Peres Projects, Berlin
and Pace London: pp.94–95
Courtesy the artist and team
(gallery, inc), New York: p.96
Courtesy of Sue and Malcolm
Knapp: p.98
© The Irving Penn Foundation/
Victoria and Albert Museum,
London: p.100

Photography Credits

Ethan Palmer: p.19
Hans-Georg Gaul, Berlin, 2015:
pp.28–29
© 2015 Christie's Images
Limited: p.30
Bill Orcutt: p.37
Andy Keate: p.38
Turi Kirknes: pp.40, 45, 97
Noah Da Costa: pp.42–43,
70–71, 98
Ygnacio Rivero: pp.56–57
Andrea Bowers: p.58
Michael Brzezinski: pp.79, 82
Øystein Thorvaldsen/HOK: p.81
Dexter Premedia, London: dust
jacket (inner)

Great care has been taken
to identify all image copyright
holders correctly. In cases
of errors or omissions please
contact the publishers so that
we can make corrections in
future editions.

Acknowledgements

My heartfelt thanks to all the
artists, galleries and lenders who
have generously loaned the works
in this exhibition. Curating
Making & Unmaking has been a
true labour of love and I would
like to thank Jenni Lomax for
this opportunity to be part of
Camden Arts Centre's revered
programme. Special thanks to
Gina Buenfeld for her dedication
and tenacity, as well as Charlotte
Juhen and Ragnhild Furuseth.
Thank you to Glenn Ligon for his
insightful interview and Jennifer
Higgie and Shanay Jhaveri for
their brilliant essays.

Additional thanks to Cockayne
– Grants for the Arts and The
London Community Foundation;
Marina Bassano; Cranford
Collection; Nicholas Cullinan;
Thomas Dane; Okwui Enwezor;
Eliane Fattal; Nicholas Fox
Weber; Mala Gaonkar; Oliver
Haarmann; Oscar Humphries;
Alison Jacques; Pamela S Johnson,
The Destina Foundation; Emelia
Kenlock; Jeanne Greenberg
Rohatyn; Nick Rohatyn; and
Lynette Yiadom-Boakye.

For their contributions to the
catalogue, thanks to Karsten
Schubert, Doro Globus and
Daniel Griffiths at Ridinghouse
for their diligence, expertise and
constant enthusiasm; and the
team at A Practice for Everyday
Life for the superb design of this
book; as well as Eileen Daly;
Richard Deal; and Kitta Roos.

Thank you to my dear parents
Inez and Kayode Olowu, for
lovingly indulging my curiosity
from childhood and teaching
me about instinct and intuition;
and finally to my wife Thelma,
who passionately and brilliantly
encourages my multiple creative
endeavours in ways that make
me feel unbelievably lucky
and content.

Duro Olowu

Published in 2016 by Ridinghouse
and Camden Arts Centre

on the occasion of
Making & Unmaking
Curated by Duro Olowu
19 June – 18 September 2016

Camden Arts Centre
Arkwright Road
London NW3 6DG
United Kingdom
camdenartscentre.org

Director Jenni Lomax
Exhibition Gina Buenfeld; Charlotte Juhen
Installation Scott Brotherton; Milo Brennan
Public Programme Nisha Matthew
Education Gemma Wright; Amelia Martin
Development Neil Debnam; Sandie Mattioli
Communications Lia Kent Mackillop; Rosie Gibson

Exhibition Supporters

Cockayne – Grants for the Arts and
 The London Community Foundation
LUMA Foundation
Charlotte and Alan Artus
Mala Gaonkar and Oliver Haarmann
Guy and Alexandra Halamish
Laurie Fitch
Yana and Stephen Peel
Thomas Dane
Thomas Dane Gallery
Sara Tayeb-Khalifa
Nicola Blake
and other members of the Duro Olowu
 Exhibition Circle

Ridinghouse
46 Lexington Street
London W1F 0LP
United Kingdom
ridinghouse.co.uk

Publisher Doro Globus
Publishing Manager Louisa Green
Publishing Associate Daniel Griffiths

Distributed in the UK and Europe by
Cornerhouse Publications
HOME
2 Tony Wilson Place
Manchester M15 4FN
United Kingdom
cornerhousepublications.org

Distributed in the US by
RAM Publications + Distribution, Inc.
2525 Michigan Avenue, Building A2
Santa Monica CA 90404
United States
rampub.com

Editors Duro Olowu, Gina Buenfeld and Doro Globus
Assistant Editor Daniel Griffiths
Proofreader Eileen Daly
Designer A Practice for Everyday Life
Printer Albe De Coker, Belgium

Images © the artists, unless noted on pp.110–11
Texts © the authors
For the book in this form © Ridinghouse and
 Camden Arts Centre

ISBN 978 1 909932 27 2

British Library Cataloguing-in-Publication Data:
A full catalogue record of this book is available
from the British Library.